Contents

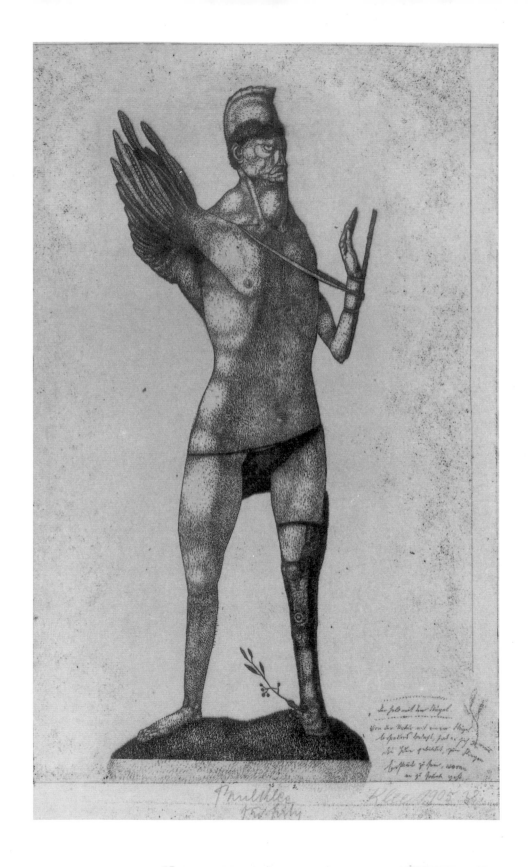

Susanna Partsch

PAUL KLEE

1879–1940

TASCHEN

KÖLN LONDON MADRID NEW YORK PARIS TOKYO

© 2000 Benedikt Taschen Verlag GmbH
Hohenzollernring 53, D–50672 Köln
www.taschen.com
© 1993 VG Bild-Kunst, Bonn, for the reproductions
English translation: Hilary Schmitt-Thomas
Edited and produced by: Brigitte Hilmer
Cover design: Catinka Keul, Angelika Taschen, Cologne

Printed in Germany
ISBN 3–8228–5981–8

Musician or Painter

"I cannot be grasped in the here and now. For my dwelling place is as much among the dead as the yet unborn. Slightly closer to the heart of creation than usual, but still not close enough. Do I radiate warmth? Coolness? There is no talk of such things when you get beyond white heat. The further away I am, the more pious I am. Here and now I sometimes delight in the misfortunes of others. There are shades of difference for the one cause. The clerics are just not pious enough to see it. And the scribes, they take just a tiny bit of offence."[1]

These words by Paul Klee briefly characterize the artist and the man – as he wanted to be seen. They could almost be called his manifesto.

Paul Klee made a point of cultivating the image he wished the public to have of him. He kept a diary from 1897 until 1918; with the exception of the last volume, covering the years 1916 to 1918 and mainly containing copies of letters to his wife, he edited them with publication in mind. At one point (Diaries, 900)[2] he even directly addressed the reader. He was already giving extracts from his diaries to his first biographers in 1920.

The passage quoted above has always wrongly been assigned to his diaries. It was first published in the catalogue of his first big one-man exhibition at the gallery of art dealer Hans Goltz in Munich and then in the first monograph on Paul Klee by Leopold Zahn. In this passage, Klee succeeded very early on in having himself portrayed as he wanted to be seen – and as he probably saw himself. Even one of his friends, the art historian Will Grohmann, who later became his biographer and whose major monograph was not published until 1954[3], described the artist and his work without any critical distance. The image of Klee thus created has repeatedly been reproduced.

It was not until the mid-70s that Jürgen Glaesemer and Christian Geelhaar ushered in a new era of Klee research, making possible a more objective view of the painter[4]. Geelhaar in particular, with his critical edition of the writings, opened up the possibility of subjecting the work and life of Paul Klee to a new analysis. The first to take on this task was Otto Karl Werckmeister, a German art historian living in the USA. He published his research on Klee, which also covered the artist's political and social milieu, in a series of essays since 1976, and subsequently added to these essays for the period 1914–1920 and published them in book form.[5] Art historians from America and the

Self-Portrait, 1899, 1
Selbstbildnis
Pencil on paper, 13.7 × 11.4 cm
Felix Klee Collection, Berne

The Hero with the Wing, 1905, 38
Der Held mit dem Flügel
Etching, 25.4 × 15.7 cm
Städtische Galerie im Lenbachhaus, Munich

German-speaking countries have followed this new lead on Klee, thus considerably shaking previous interpretations. A critical edition of Klee's diaries, published in 1988 by Wolfgang Kersten,[6] has contributed to this development.

Paul Klee grew up in a family of musicians. His father, Hans Klee (1849–1940), came from Thann in the Rhön mountains. After training to be a teacher in Franconia he went to Stuttgart to study singing, piano and violin at the conservatorium. There he met Ida Frick (1855–1921) from Basle, who was training to be a singer. They got married in 1875. Hans Klee was a music teacher at the Berne State Seminar in Hofwil until 1931.

Their daughter Mathilde was born in 1876, followed by their second and last child, Paul, on 18 December 1979. In 1880 the family moved from Münchenbuchsee (Canton of Berne) to Berne, where they also moved several times before they could afford to buy a house of their own in 1897. Paul Klee was born and grew up in Switzerland, but he had German nationality like his father.

Legend has it that his Grandmother Frick introduced him to pencils and paints. His childhood drawings have remained extant. He later included some of them in the list of his works.

Klee started school in 1886. He began to play the violin at the early age of seven and was soon playing it so well that at eleven he became an associate member of the orchestra that gave subscription concerts at the Berne Music Society. At the same time he was also drawing and writing poems. Unlike his musical ability, though, his talent for drawing was not given any particular encouragement. So we cannot say which of his gifts was greater. His choice of profession was not least the result of opposition to his parents, who wanted him to become a musician. "I would have gladly left school during the last year but one, but my parents' wishes prevented me from doing so. I now felt like a martyr. I only liked what I was not allowed to do. Drawing and writing. After I had scraped through my school-leaving examination, I began to paint in Munich," he wrote in retrospect in his diary (Diaries, 63). Apart from his revolt against his parents'

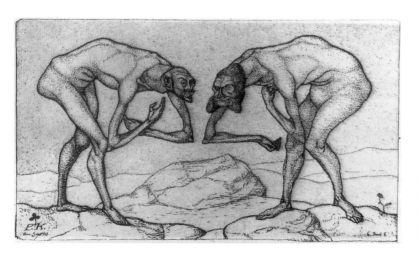

Two Men Meet, Each Believing the Other to Be of Higher Rank, 1903, 5
Zwei Männer, einander in höherer Stellung vermutend, begegnen sich
Etching, 11.8 × 22.4 cm
Städtische Galerie im Lenbachhaus, Munich

Virgin in a Tree, 1903, 2
Jungfrau im Baum
Etching, 23.6 × 29.6 cm
Städtische Galerie im Lenbachhaus, Munich

music cult, this decision was also "the first step towards the emancipation of art as part of accepted culture."[7]

Beside the emancipatory aspect, there was for Klee another reason for his decision. He felt that music had passed its peak; modern composers left him cold. "I didn't find the idea of going in for music creatively particularly attractive in view of the decline in the history of musical achievement."[8] And yet he remained loyal to the music that he had known since his earliest childhood. He played the great composers of the 18th and 19th centuries, first in an orchestra and then privately with friends. Arnold Schönberg and his circle never meant anything to him.

Many people have established a connection between Klee's musicality and his painting, thus completely misunderstanding the facts of the case. As a musician, Klee worked reproductively and traditionally. As a creative painter, on the other hand, he was radical. For him, music and painting were not of equal standing, although it is frequently assumed that his decision in favour of painting says otherwise. In

9

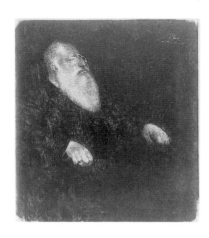

Portrait of my Father, 1906, 23
Bildnis meines Vaters
Indian ink drawing behind glass, 32 × 29 cm
Felix Klee Collection, Berne

"The subject in itself is certainly dead. What really counts now are the sentiments. The growing fashion for erotic subjects is not just a French affair, but rather a preference for subjects most likely to provoke the sentiments. As a result the external form becomes extremely variable and moves along the entire scale of the temperaments – according to the mobility of the index finger, one might say in this case. The technical means of representation vary accordingly. The school of old masters is certainly over and done with."

Paul Klee, Diaries, July 1905

his choice of profession he was probably also influenced by a desire to be creative and the conviction that this would only be possible in the field of fine arts – and not as a musician.

While at school, Klee had mainly drawn. There are numerous caricatures to be found in his surviving schoolbooks. He took his school-leaving examinations and left in September 1888, moving to Munich in October to study at the Munich Academy. The director refused to admit him, however, and advised him to get more practice in drawing figures at the private art school of Heinrich Knirr (1862–1944). His parents were disappointed. They had bought a house and were finding it difficult to give their son financial support – which they would probably have to do for longer than they had planned.

In his letters, Klee defended his lodgings, which were too expensive, and on 21 October, after two days' tuition, was already hinting that it would probably be better for him to stay at Knirr's school for two years before going to the Academy. Then, he declared, he would start tuition with Franz von Stuck right away. Klee had to overcome considerable opposition from his parents before they would approve of his plans.

Reading his letters to his parents[9], we have the impression that Klee's life in Munich consisted of his studies with Knirr and his own studies, of concerts, operas and the theatre, of music-making with friends. He kept a record of his expenses, but never seemed to know where his money all went. But in his diary he wrote of self-realization, of sexual distress and nights spent drinking: ". . . other matters, questions concerning my very existence, became more important than glory in Knirr's school. There were even times I didn't turn up at class . . . In short, I first had to become a man; art would then follow as a matter of course. And relations to women were, of course, all part of it." (Diary, 66) "Inspection of myself, farewell to literature and music. Efforts at attaining more sophisticated sexual experience abandoned in one single instance. I hardly think about art, I only want to work at my personality. In this I must be single-minded and avoid all public attention. The most likely outcome is that I will find expression in the fine arts. A little booklet, a kind of catalogue with all the sweethearts I didn't get, provides an ironical reminder of the great sexual question." (Diaries, 83)

In December 1899, at a musical evening in the house of friends of his parents, he met the pianist Lily Stumpf (1876–1946), with whom he then spent a lot of time making music and going to concerts. He was very attracted to her, certainly, but at the same time he was still living in two worlds. On the one hand he cultivated the musical life of the educated bourgeoisie he already knew from his own home. It was in this sphere that he met the daughter of a medical officer of health called Stumpf. On the other hand he spent whole nights in Munich pubs and had affairs with women from other social classes, such as a shop girl and a nude model. One such affair even resulted in the birth of a son in November 1900; the boy, however, only lived a few weeks. In this respect, Klee's life very much conformed to the bourgeois convention of the day, whereby pure and noble love was to be

found in one's own circle and allowed to grow slowly, while at the same time sexual experience was to be had in other quarters. To the same degree that the one type of woman – ladies of society – was courted, the others were degraded. ". . . the whole affair had been entirely to my taste. Cenzi [a nude model] didn't want any lover's vows. She even addressed me with the polite 'Sie'. I used the familiar 'du' and always found her to be an even-tempered and reasonable creature. Not a trace of vulgarity in her." (Diaries, 127)

Klee joined the painting class of Franz von Stuck (1863–1928) in October 1900. Wassily Kandinsky (1866–1944) was also studying there at this time, but the two did not meet as Klee was usually conspicuous by his absence. Although he wrote to his parents on 22 October that Stuck's corrections were "sharp, but clever and well-meaning," he gained little from the lessons. He left the class in March 1901 and tried to gain admission to the department of sculpture. He refused to take the entrance examination, however, and so left Munich that summer. Before this departure he secretly got engaged to Lily Stumpf.

During these three years in Munich, he had acquired a certain proficiency in drawing and had also taken an interest in the techniques of etching. But he had acquired no skill in painting. It was not as a painter but as a draughtsman that he returned to his parents' home in Berne. From there, he wrote Lily long letters in which, inter alia, he talked about his relation to his parents. These letters are in contrast to the image created by his biographer, Will Grohmann, who had been given his information mainly by Klee himself. In Grohmann's biography, we read that Klee greatly suffered from his father's sarcastic sense of humour, but enjoyed mutual understanding with his mother, a sensitive woman. This is a cliché that has been around in the biographies of artists for centuries. The fact is, however, that in the summer of 1901 Klee himself described his relations to his father very favourably – ("Father is my favourite. I like him") – and spoke of his sickly mother in a somewhat distant fashion. Significantly enough, Lily Stumpf also cultivated frailty in later years, a development Klee started criticizing after a while.

In October 1901, with Hermann Haller, whom he had known since his school days and with whom he had studied in Munich, Klee set off for Italy for several months. They spent most of the time in Rome. Klee studied the Old Masters, drew and made music, and also went to Naples and Florence. He returned to Berne in May 1902, where he spent the next few years living with his parents and continuing his studies on an autodidactic basis. He went to a course on anatomy, a lecture on "Plastic Anatomy for Artists" and an evening life class.

In July 1903 he began work on a cycle of eleven etchings, called *Inventionen (Inventions)*, which he finished early in 1905 (p. 6, p. 8, p. 9, p. 13). After spending a fortnight in Paris, during which time he met the Impressionists – but not Paul Cézanne (1839–1906) or modern contemporaries like Henri Matisse (1869–1954) or André Derain (1880–1954) – he began experiments in which he drew with a needle

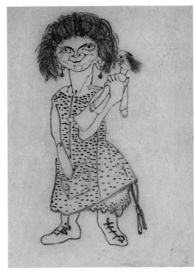

Girl with Doll, 1905, 17
Mädchen mit Puppe
Watercolour, backed by layer of white, behind glass, 17.7 × 12.9 cm
Paul Klee Foundation, Kunstmuseum, Berne

on a blackened pane of glass. He made a portrait of his father using this technique (p. 10). From this, Klee developed his glass-pane technique, where it was not so much the colour that is the focus of interest, but the contrast between dark and light.

In his fifty-seven glass-pane drawings in all, Klee attempted to unite etching and painting, as can be seen in his picture *Mädchen mit Puppe (Girl with Doll*, 1905 – p. 11). In his diary, he gives a brief and concise description of how his glass-pane pictures are made: "Ingenious glass-pane technique: 1) cover the pane evenly with white tempera, perhaps by spraying on a diluted mixture; 2) after it has dried, scratch the drawing into it with a needle; 3) fix it; 4) cover the back with black or coloured areas." (Diaries, 760). In June 1906 his *Inventionen* were displayed as part of an international exhibition of the Munich Secession. A critic wrote in the *Berner Rundschau* of "the crazy anomaly" of forms.

Paul Klee and Lili Stumpf married in September 1906, and on 1 October moved into a small flat in the Munich suburb of Schwabing. Lily gave piano lessons, Klee painted and kept house. Even in Berne he had given some thought to the division of labour: "We will both simply have to work. For how long, I don't know. I just cannot be measured by bourgeois standards." (Diaries, 757) However, his attempts to contribute to their income by earning money, such as by working as an illustrator for *Simplizissimus* magazine, were unsuccessful.

It has frequently been noted that Klee's artistic development progressed extremely slowly. His years in Berne mainly produced his eleven *Inventionen* and his glass pictures with their experiments in tonal value. Attempts at oil painting brought technical progress, but the results did not satisfy him. In his letters to Lily, Klee on the one hand repeatedly emphasized how much work he was doing; on the other hand, however, these letters largely consist of descriptions of concerts. Klee had again started to play the violin in an orchestra, wrote reviews of plays and concerts for the *Berner Fremdenblatt* and read a great deal. It is likely he spent as much time on his musical activities – after all, there were also rehearsals – as he did on developing his artistic skills.

He had next to no contact with the currents of modern art. It was not until 1905 that the draughtsman and illustrator Jacques Ernst Sonderegger (1882–1956) drew his attention to Henri de Toulouse-Lautrec (1864–1901), Edvard Munch (1863–1944) and James Ensor (1860–1949). It is very possible that the atmosphere at home hampered his artistic development. But Klee was not prepared to give up the music that was still of prime importance in the home of his parents. He had, certainly, made a decision in favour of the fine arts, but he was not willing to forfeit his other passions. The time he spent on music, and hindrances in his parents' home, are possibly reasons why Klee took relatively long to find his feet as a painter. Nothing much changed for a while in Munich, either – for then there was his son, Felix, who stole the time he really needed if he was to get on more quickly.

Aged Phoenix, 1905, 36
Greiser Phönix
Etching, 27.2 × 19.8 cm
Städtische Galerie im Lenbachhaus, Munich

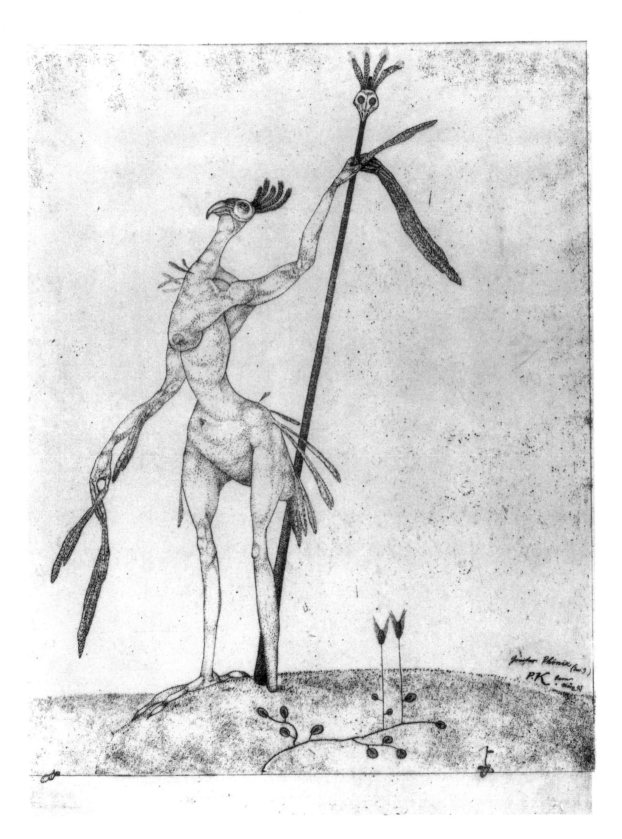

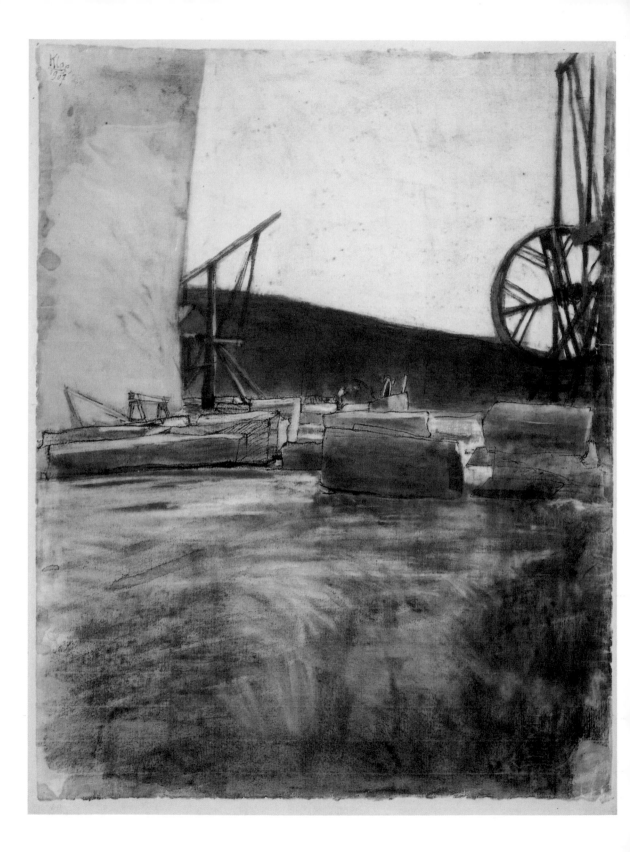

The Househusband – from Draughtsman to Painter

Paul Klee and Lily Klee-Stumpf lived in a three-roomed flat in Schwabing and were relatively unaffected by events in the world of the arts. Lily gave piano lessons but does not seem to have given concerts as in previous years. At least, if she did, they are not mentioned again. Their only son, Felix, was born in November 1907. Klee was largely in charge both of his upbringing and of the housekeeping. Until 1915, he regularly took Felix to Berne in the summer and often stayed there for more than three months, with Lily usually only joining them for a few weeks. Klee's letters indicate that in Berne he had more time for his own activities, for there he could entrust Felix to his sister or parents for a while. Otherwise, the letters Klee wrote to Lily from Berne are mainly detailed descriptions of his son's well-being and development.

Portrait of a Pregnant Woman (Lily), 1907, 19
Bildnis einer schwangeren Frau (Lily)
Indian ink behind glass, 27 × 32 cm
Felix Klee Collection, Berne

He also kept records in his diary of the progress made by the little boy. During the first year he kept a "Felix calendar", in which he wrote down the child's weight, first teeth, his motor and speech development. One of his entries made in November 1908 is typical of his reflections: ". . . says oli-yoli-yoli togadoh, togadohdoh, tod yah-doh! (Are irritations from teething and learning to talk somehow connected?)" ("Felix Calendar": Diaries, 841). When Felix became seriously ill between February and May 1909 and only an operation could save him, Klee daily recorded his temperature, doctor's visits and prescribed medicines. When Felix had recovered, Klee came to the conclusion, "This illness interrupted everything, as can be seen from the above lines. I completely took charge of the child's care. Only during the worst period did I allow a nurse to take my place. Olga Lotmar also helped me a lot – very ably, of course, being a doctor." (Diaries, 855) It seems that Lily was scarcely involved in nursing the child, and, as far as this is concerned, she is not mentioned once in Klee's diary.

With this division of labour, the Klees had broken away from bourgeois conventions. Nowadays, Klee would be called a houseshusband. Such a division of labour is now gradually being accepted, but it was still extremely unusual at the beginning of the century. Perhaps his art was influenced by these years spent bringing up his son. His "infantile" art and his search for the tradition of childhood are always being emphasized by critics. Art historians, most of whom are men, are only now beginning to allow that this aspect of Klee's art may

In the Ostermundingen Quarry, Two Cranes,
1907, 23
Im Ostermundinger Steinbruch, zwei Kräne
Charcoal, pen drawing in Indian ink, watercolour on paper, mounted on cardboard,
63.1 × 48.6 cm
Paul Klee Foundation, Kunstmuseum, Berne

15

also have something to do with the years he spent as a househusband.[10] The fact of the matter is that Klee made very little headway with his art, even during his first years in Munich. His activities in the home will certainly have cost him a lot of time and energy. He protested when, in autumn 1910, Lily wanted to start giving more lessons. He wrote to her on 25 October from Berne, "Who's to do the housework – just me? That's not on. Half a day, yes; but I can't give the whole day."

Until then, he had still not had any real success. One or two pictures had been displayed in big exhibitions, and there was even a one-man exhibition in Switzerland in 1910 with fifty-six pictures shown in Berne, Zurich and Winterthur. But financially all this had had little effect. The few pictures he sold and his work as a corrector at an evening life class allowed him to make but a small contribution to the family's income.

During his early years in Munich, Klee was not only occupied with his graphic work, but also continued experimenting with colours. The content of a picture was becoming increasingly unimportant; what mattered was its form. He occupied himself more extensively with the question of tonality in his black watercolours, a process he had begun in his glass-pane paintings. He also attempted to conquer colour by painting in tonal shades. He started combining the graphic techniques in which he was skilled with colours. Thus in his pen drawing *Im Ostermundinger Steinbruch, zwei Kräne* (*In the Ostermundingen Quarry, Two Cranes*, 1907 – p. 14), he not only used charcoal but also watercolours. The use of paint, in gradated shades of green, blue and brown, was limited to isolated areas, without any overlapping. Klee not only divided areas within the picture from each other by means of lines but, by using colours of differing degrees of lightness, also structured and delimited them. This clarifies the term "tonality" as understood by Klee at the time.

Klee then became interested in Impressionism, among other things. But unlike many of his contemporaries, he did not adopt the style of the Impressionists only to put it behind him again. Instead, he examined their principles so that he would be able to include them in his experiments in painting in dark and light. Light as the main bearer of everything visible, as the Impressionists saw it, was for Klee not bound to the phenomenon of colour. Klee was far more concerned with the problems of tonality. The representation of light was of much greater help to him in his attempts to come to terms with light-dark values and resulted in him developing his black watercolours.

After working at these problems, he again started spending more time on oil painting. He wanted a clean break with naturalistic painting, although he repeatedly went back to this style to get his bearings, and for training purposes. He set up rules for himself in his diary, adding principles that influenced his later work. His aim was not the representation of outer reality. Rather, the aim was for association and imagination to give rise to the emergence of the picture from the first layers of paint applied to the canvas. He remembered how, when he was nine, he would trace with his finger the patterns on the marble ta-

bles in his uncle's restaurant until he could recognize shapes and figures. Klee attached great importance to this boyish habit. In his pictures he wanted to reconstruct generally valid laws with the means of painting. It is very possible he was already being guided by the maxim, "Art does not reproduce the visible, but makes visible", which he was to use as the epigraph to an essay in 1920.

As in his black watercolours, he also started to apply one layer of paint on top of another in his coloured works, to attain certain tone values. He not only produced superficial and rapidly worked watercolours, but also oil paintings like *Weiblicher Akt* (*Female Nude*, 1910 – p. 21). Apart from his involvement with colour, he also spent a great deal of time on his graphic work. He was still more a draughtsman than a painter. It is therefore hardly surprising that his first important contact with an artist was one of the few graphic artists of the time – Alfred Kubin (1877–1959), who in December 1910 asked Klee if he could select some of his etchings. This was the beginning of their association. Kubin visited Klee in January and encouraged him in his plan to illustrate Voltaire's *Candide*, which he had read some years previously. In these drawings, Klee achieved the style he had long been trying to attain. The form was the important thing for him. It was not until he was actually working on the illustrations, or perhaps even after he had finished them, that the contents took on a meaning.

1911 brought Klee important contacts. In September he met August Macke (1887–1914) in Berne, and in the late autumn Wassily Kandinsky in Munich, whom he had already been living near for three years. He met both through his old friend Louis Moilliet (1880–1962) from Berne, who was also a painter. Kandinsky introduced him to some of the artists that had joined forces in 1909 to set up the Neue Künstlervereinigung München (NKVM – the New Munich Society of Artists). Apart from his meeting with Gabriele Münter (1877–1962), who was then Kandinsky's companion, with Alexei von Jawlensky (1864–1941) and Marianne von Werefkin (1860–1938), Klee's friendship with Franz Marc (1880–1916) was particularly crucial.

In those days, Kandinsky and Marc were busy editing an almanach entitled *Der Blaue Reiter*. This collection of essays was to be a "collecting place for all those endeavours that have now become so apparent in all fields of art and the basic intention of which is to extend the previous limits of artistic expression."[11] This "almanach" (only one volume was ever published) is now regarded as one of the most important manifestos of 20th century art.

The first exhibition of Der Blaue Reiter was held in December 1911 in the Galerie Thannhauser in Munich after Kandinsky, Marc and others sharing the same ideas had left the Neue Künstlervereinigung, which was holding its big annual exhibition at the same time in this very gallery. Klee, who participated in neither of the exhibitions, wrote a review for *Die Alpen*, a monthly journal published in Switzerland and edited by his friend Hans Bloesch (1878–1945). Here he expressed his convinced support of "primitive art": "There are indeed very early forms of art around more likely to be found in ethnological museums or at home in the nursery (laugh not, dear reader), for chil-

Portrait of a Child (Felix), 1908, 64
Kinderbildnis (Felix)
Drawing with black watercolour, 30 × 24 cm
Felix Klee Collection, Berne.

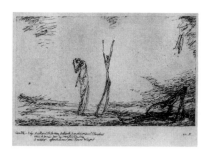

"Quelle peut être la raison . . .", 1911, 81
Illustration for Voltaire's *Candide*
Pen and Indian ink on paper, 13.7 × 22.2 cm
Paul Klee Foundation, Kunstmuseum, Berne

dren can paint like this as well. This is by no means a scathing criticism of the efforts of the very young – there is a great deal of positive wisdom in this circumstance. The more helpless these children are, the more educative their art, for even at this stage there is corruption – when children start to absorb, or even imitate, developed works of art. The drawings of the mentally disturbed are a parallel phenomenon – thus madness is not an appropriate term of abuse. The truth is that all these paintings should be taken far more seriously than all our art galleries – *if* it is a matter of reforming the art of today."[12]

This excerpt shows that Klee had ideas about art similar to those of the editors of *Der Blaue Reiter*. The almanach was published in May 1912 and, apart from illustrations of modern art, contained objects by primitive people and children's drawings. Hans Prinzhorn's book on *Pictures by the Mentally Disturbed*, which was to be so influential in the 1920s, had not yet been published.

Klee's artistic isolation had been broken. He had met painter colleagues sharing similar views, and they had an important effect on his work. In 1926, in an article in the catalogue for Wassily Kandinsky's 60th birthday exhibition, he wrote in retrospect, "His age of development was above mine. I could have been his pupil, and to a certain degree was, because much of what he said was able to shed a soothing light on my search and confirm it. What he said was obviously not merely words without the response of deeds [Kandinsky's earlier compositions]."[13] In the Blauer Reiter exhibition he not only saw works by the organizers, but for the first time also pictures by the French artist Robert Delaunay (1885–1941), which must have made a big impression on him, even though he did not mention him in his review. The question of colour was a central point of discussion within the group. Marc and Macke had laid down their theories on colour in their letters to each other. We can assume that Klee, too, talked about this topic with his friends in Munich.

Shortly afterwards, in February 1912, the second and final exhibition of Der Blaue Reiter was held at the Goltz Gallery, Munich, and was limited to graphic art and watercolours. Klee had seventeen pictures in it. This exhibition was even more international than the first one, and for the first time Klee was confronted by such French Moderns as Georges Braque (1882–1963) and Pablo Picasso (1881–1973), the Russian Constructivism of an artist like Kasimir Malevich (1878–1935) and also the group of artists known as Die Brücke.

In April, Paul Klee and Lily went to Paris. This time he saw works by Picasso and Braque, Derain and Maurice de Vlaminck (1876–1958). He went to see Robert Delaunay in his studio. Delaunay had turned his back on Cubism and for him colour was the most important component in the picture. Thus, in 1912, he found his way to "pure painting" – abstract pictures. Apart from the relationship between the complementary colours (i. e. the colours opposite each other on the colour disc), he was especially concerned with the problem of simultaneous contrast (which is based on the fact that the eye automatically yearns for the complementary colour of any given colour and "creates" it if it is not available). Not only Klee, but also

"Of more importance than Nature and the study of Nature is one's attitude to the contents of one's paintbox. One day I positively must be able to indulge in free fantasias on the colourful keyboard of a row of watercolour paints." *Paul Klee, Diary, March 1910*

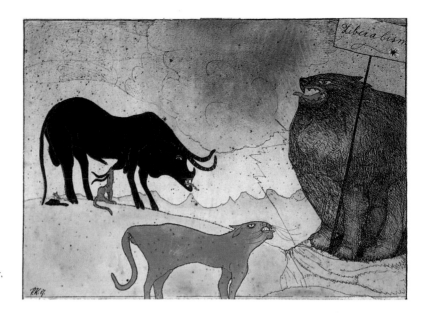

The Concert of the Parties, 1907, 14
Das Konzert der Parteien
Watercolour over pen and Indian ink on paper,
24.2 × 33 cm
Paul Klee Foundation, Kunstmuseum, Berne

Marc and Macke went to see the Frenchman in autumn 1912; they were greatly impressed by his experiments with colours and incorporated them in their artistic work, each in his own way.

In 1913, Paul Klee translated Delaunay's essay "On Light" for Herwarth Walden (1878–1941), the editor of the periodical *Der Sturm* in Berlin. (By then, he was also in charge of Der Sturm gallery in Berlin, where Klee started selling his paintings successfully). Klee drew on the ideas in Delaunay's essay for his own work.

Klee was now member of the avant-garde that exhibited in the Sonderbund show in Cologne in 1912. He was commissioned by Marc and Macke to organize the Swiss contribution for the First German Autumn Salon (1913 in Der Sturm gallery). He himself participated in the exhibition with eight watercolours and fourteen drawings. Klee was perhaps not in the very limelight of the world of avant-garde art like Kandinsky and Marc, neither did he fight as vehemently for the new art as Marc did; but the image of the retiring artist working in seclusion, hidden away from the outside world, was not as true for the years prior to the First World War as he would have people believe. His contacts grew in number, and from the list of his works we can see how many pictures he sold.

In 1911, at the same time that he started copying and editing his first diaries, he compiled a list of his pictures. He put a great deal of painstaking work into including the works he had created before this period and even added some of his childhood pictures his sister had kept for him and which he considered important. He wrote in his diary, "What a lot an artist must be: poet, naturalist, philosopher! And now I've become a bureaucrat, too, by compiling a large, detailed catalogue of all my artistic products ever since my childhood. I have only left out my school drawings, studies of nudes, etc. because they

lack creative self-sufficiency." (Diaries, 895) He numbered the pictures consecutively for each year. He noted which ones were modelled on nature (B) and which he regarded as pure invention (A). Pictures he found particularly important or which he thought were trend-setting he marked as "Special Class" (S.Cl.) and kept; most of them are now in the Paul Klee Foundation or the Felix Klee Collection, both in Berne. A picture that had been sold was marked with its price and details of the owner.

His new meetings, especially his involvement with Delaunay, gave decisive impetus to his artistic development. As far as painting techniques were concerned, he had acquired a lot of knowledge by his involvement with black watercolours. By now, he was also familiar with problems concering the disintegration of shapes in colour patches, the glazing of paints and playing with surface stimuli. The only thing he did not manage to do was to transfer motifs from the world around him to autonomous colour compositions. He had already given a lot of thought to this problem, and Delaunay's essay "On Light" had confirmed his views. But his attempts to put his views into practice seemed artificial, as can be seen in the watercolour entitled *Berghang* (*Mountain Side*, 1914). It has been directly connected to a passage in Delaunay's essay: "As long as art cannot get free of the object, it will continue to be a description, literature – will degrade itself to become the handmaiden of imitation. And this is also true even if it emphasizes the light effect of an object or the light effects of several objects without the light rising to become artistically self-sufficient."[14]

Klee had definite ideas about how to use colour and tried to put them into practice in his pictures. But he himself realized that these attempts seemed construed. He did not succeed in creating what he envisaged naturally, spontaneously, but only with a concerted effort.

This is not a phenomenon only Klee had to contend with; it is characteristic of many artists. Intellectually, Kandinsky had already taken the final step to abstract art in his book *Über das Geistige in der Kunst (Concerning the Spiritual in Art)* before he actually managed to put his views into practice. It is often something very trivial that suddenly allows an artist to create something that both he himself as well as other people regard as being his own independent work. This is not divine inspiration, as is often claimed; years of experiment and struggle usually precede the successful breakthrough.

With Klee, it was the trip to Tunisia in 1914 that showed him the way to painting independently. He himself felt this to be so when he wrote in his diary, "Colour possesses me. It will always possess me. That is the meaning of this happy hour: colour and I are one. I am a painter." (Diaries, 926 o). Now, at last, he was convinced that his experiments and struggles with colour had led the way to satisfactory results. These lines in his diary have usually been interpreted differently, though: "The legendary trip to Tunisia only lasted twelve days and yet it opens a new chapter. Klee starts thinking about colour, which now brings more distance between him and nature and being than his drawings, refers him to 'creation as the genesis below the surface of a work' and the 'cool romanticism of abstraction'."[15]

Female Nude, 1910, 124
Weiblicher Akt
Oil on cotton cloth mounted on cardboard,
38.9 × 25 cm
Paul Klee Foundation, Kunstmuseum, Berne

20

1910. 124. akt

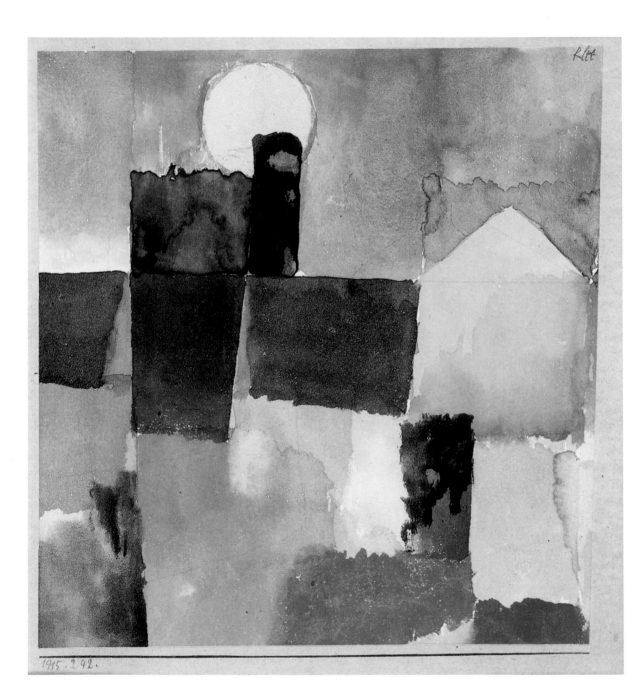

Klee

1915.2.42.

The Trip to Tunisia

In April 1914, Paul Klee, August Macke and Louis Moilliet went to Tunisia together. This journey has been described many times. Moilliet knew a Swiss doctor in Tunisia, Dr. Ernst Jäggi (1878–1941), who had often invited him to go and stay with him. Moilliet had already taken up this invitation in 1908 and 1909/10. He had already planned to go to Tunisia with Klee in 1913, but at that time the trip had had to be postponed. It seems that Moilliet suggested his friend went without him, for Klee wrote to him from Munich in May 1913: "Going to Tunisia by myself was not what I really had in mind. I was hoping it would be a real study trip, with each of us giving stimulation and ideas to the other."[16] So Klee was expecting more from such a trip if he went with painter friends than by going alone. It is therefore hardly surprising that it was he who again took the initiative. He spent that Christmas with his family in Berne and, on 8 January 1914, travelled to Lake Thun, where Moilliet had been living in Gunten since 1910. Macke and his family had settled nearby in Hilterfingen for a good half year. They met in Macke's home, where Klee mentioned the cancelled trip and was able to persuade the two other men to renew their plans. With Moilliet's help, Klee was able to sell enough pictures to a pharmacist in Berne to pay for his trip.

On 3 April 1914, Klee took Felix to Berne, took receipt of the money and, together with Moilliet, travelled to Marseille, where they arrived on 5 April. Macke was already waiting for them. They reached Tunis on 7 April. Klee had great reservations about Dr. Jäggi, who only ever talked of Switzerland: "Dr. Jäggi, comical, dry, sober, feels alienated. Can only feel climate and money. Yearns for Switzerland, is stranger to me than any Arab beggar." (Diaries, 926 e)

After spending three days in Tunis, during which Macke and Klee, with police protection, drew and painted in the Arab quarter and the harbour, they travelled to the doctor's country estate in St. Germain. From there, together with Jäggi, they drove by car to Sidi-Bou-Said and Carthage. On 14 April, the three painters took the train first to Hammamet and from there to Kairouan. There Klee had that breakthrough to painting he described in his diary. He refused to absorb even more and returned to Tunis earlier than planned. Macke and Moilliet went with him, but spent a few days longer in Tunisia than Klee, who embarked for Naples on 19 April. He was back in Berne on the 22nd and in Munich on the 25th.

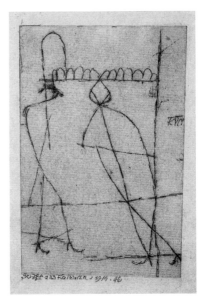

Sketch from Kairuan, 1914, 46
Scizze aus Kairuan
Pen on Italian paper, 5.8 × 10.5 cm
Paul Klee Foundation, Kunstmuseum, Berne

Moonrise at St. Germain (Tunis), 1915, 242
Mondaufgang St. Germain (Tunis)
Watercolour, 18.4 × 17.2 cm
Folkwang Museum, Essen

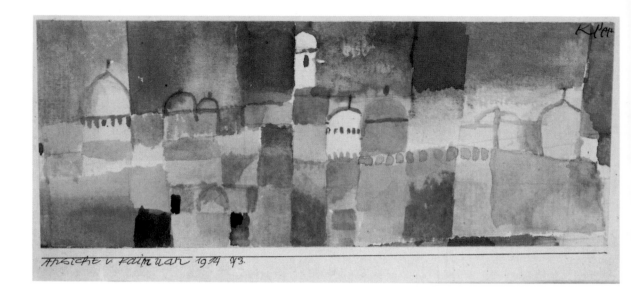

View of Kairuan, 1914, 73
Ansicht von Kairuan
Watercolour, 8.2 × 21 cm
Galerie Stangl, Munich

Klee was the only one to keep a diary of this trip (926 a–u). His account is primarily factual: how they spent the day, things said and done by their host (whom he apparently liked less and less), tricks and jokes by Macke and Moilliet, which he often could not follow – to simplify matters, he referred to them as Ma and Mo. Between all this, we keep finding remarks showing that the travelling companions discussed their painting, sharing experience and insights and probably growing closer in the process. Klee describes the approach to Tunis as an experience he shared with Macke: "The sun has a dark power. The colourful clarity on land full of promise. Macke feels it as well. We both know we shall work well here." (Diaries, 926 e) Moilliet suggested to Klee several times he paint subjects he found inspiring. In St. Germain on Easter Sunday: "The evening is indescribable. And to top it all, there's a full moon coming up. Louis is urging me to paint it." (Diaries, 926 k) And then again in Kairouan: "Louis can see colour delicacies and I am to catch them because, he says, I'm so good at it." (Diaries, 926 o)

Moilliet scarcely painted during the trip, but Klee and Macke did all the more. The two of them had met Robert Delaunay a couple of years beforehand and had studied his theories on colour. Macke had already managed to translate the results into his own visual idiom while still in Hilterfingen on Lake Thun. We can assume that while in Tunisia the artists discussed Delaunay and how his theories could be put into practice. They often also painted the same subjects together and will doubtless have discussed the results.

Was it really only the Tunisian landscape and architecture, the southern light and the colours that at least helped Klee find his way to painting? Or did August Macke play a part in the process?

If we compare the watercolours painted in Tunisia by Klee, Macke and Moilliet, we can see that Klee tended towards greater abstraction, Macke preferred brighter, more powerful colours and Moilliet painted much larger areas of colour. Other examples, such as *Kairouan III* by Macke (p. 25), *Ansicht von Kairuan (View of Kairuan)* by Klee (p. 24) and *Kairouan* by Moilliet (p. 25), are a clear indication that the three painters mutually influenced one another. The three pictures can, of course, also be examined for their differences – compared to Macke and Moilliet, Klee worked a lot with detail and delicate transitions of colour, which are vaguely reminiscent of his light-dark painting. And yet it is the common factors that meet the eye, especially if these pictures are compared to pictures painted by the three artists beforehand. It is revealing that it was not until the end of the journey that a noticeable similarity became apparent. Work and discussion bore the fruits of mutual influence in the three travellers' art.

Thus there were similarities during the trip, even though they did not become visible until relatively late. It is impossible to say in retrospect whether they were the result of direct dependence of the one on the other or more the result of an artistic process evolved jointly.

In the watercolours he painted in Tunisia, Klee worked with transparent colours applied one on top of the other. Pictures of buildings and landscapes were created by adding only a few details to a net of geometric shapes. He had to find his bearings anew in every place and get to know the subject. He repeatedly painted watercolours that were a relatively close reproduction of the real thing. It was not until he had completed this step that Klee was able to get clear of the object and work more abstractly.

One of the last pictures Klee painted on this trip, *Vor den Toren von Kairuan (Before the Gates of Kairuan*, p. 26), was painted on 16 April 1914, the very day he came to the conclusion in his diary that he was now, at last, a painter. Areas of colour in delicate shades ap-

Louis Moilliet
Kairouan, 1914
Watercolour, 22.6 × 28.6 cm
Graphische Sammlung,
Museum Ludwig, Cologne

August Macke
Kairouan III, 1914
Watercolour, 26.6 × 20.7 cm
Westfälisches Landesmuseum für Kunst und
Kulturgeschichte, Münster

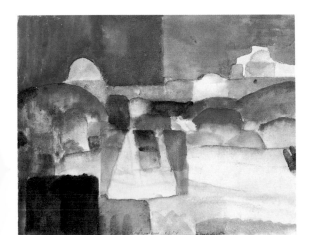

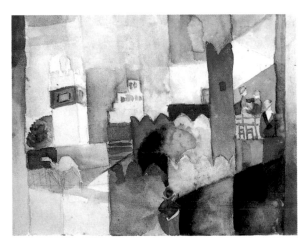

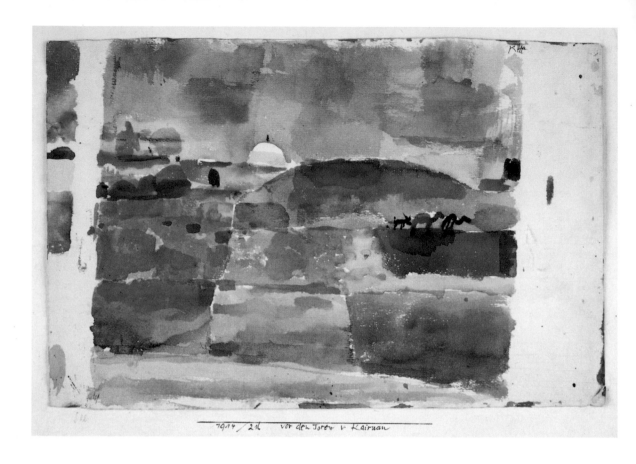

Before the Gates of Kairuan, 1914, 216
Vor den Toren von Kairuan
Watercolour, 20.7 × 31.5 cm
Paul Klee Foundation, Kunstmuseum, Berne

plied one on top of the other join together to form a view of a town. The sky and the earth become one, gradually separating if we look at the picture for a longer period of time. Two camels, a donkey, a few domes all help the eye to translate these areas of colour into a landscape, a town and sky. Once he was back in Munich, he added to the title the note that this was the "original version taken from nature".

Back in Munich he painted a purely abstract work. The title again referred to Kairouan, but the work had little similarity with the watercolour discussed above. *Im Stil von Kairouan, ins Gemässigte übertragen* (*In the Style of Kairouan, Transferred to the Moderate*, 1914 – p. 27) consists of smaller and larger rectangles, with circles painted on some of them. The colours and shapes have been variously distributed. There are smaller rectangles in muted shades of brown, green and red crowding into the left half of the picture; the shapes get larger towards the centre in brilliant yellow, red and blue, and even larger towards the right.

Green and blue dominate here, but are no longer as brilliant. The picture reminds us of a town in a landscape, possibly viewed from above. What both these pictures have in common is the kind, though not the degree of abstraction.

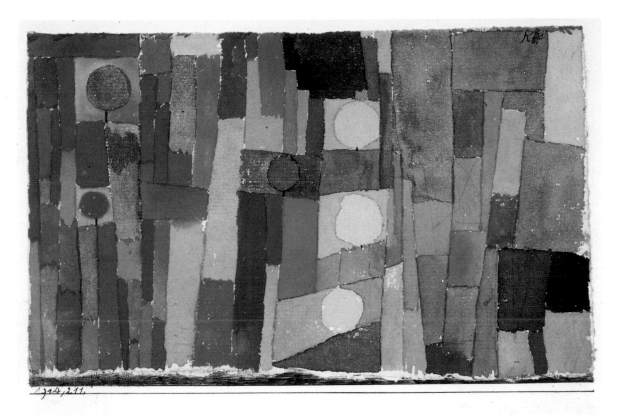

In his Bauhaus period, Klee defined abstraction in his pedagogical writings as follows: "Abstract? Being abstract as a painter is not the same as abstracting natural objective ways of comparison but, independent of these possible forms of comparison, is based on the extraction of pictorially pure relations . . . Pictorially pure relations: light to dark, colour to light and dark, colour to colour, long to short, broad to narrow, sharp to blunt, left right – up down – behind before, circle to square to triangle."[17] Jürgen Glaesemer, an authority on Klee, has interpreted these lines thus: "So Klee understood abstraction to be a requirement aimed at the way the artist painted the picture and not at the picture's message as such. He wanted the application of pictorial methods and techniques to be abstract, pure, i.e. without external disturbances, according to their own laws. The fact that abstract shapes and constellations of shapes can give rise to unlimited possible associations connected to objects does not compromise the 'purity' of the methods used, but, in Klee's opinion, is precisely what justifies them."[18]

One of the earliest oil paintings Klee did in this sense of the meaning of abstraction is *Teppich der Erinnerung* (*Carpet of Memory*, p. 29). He painted it in 1914, after the outbreak of the First World

In the Style of Kairouan, Transferred to the Moderate, 1914, 211
Im Stil von Kairouan, ins Gemässigte übertragen
Watercolour on paper, mounted on cardboard, 12.3 × 19.5 cm
Paul Klee Foundation, Kunstmuseum, Berne

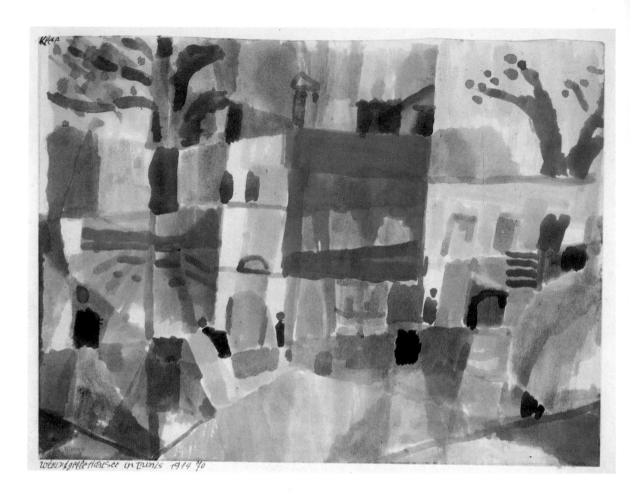

Red and Yellow Houses in Tunis, 1914, 70
Rote und gelbe Häuser in Tunis
Watercolour over pencil on paper, mounted on
cardboard, 21.1 × 28.1 cm
Paul Klee Foundation, Kunstmuseum, Berne

War. A thick, dirty looking ochre-coloured ground has been applied to untreated cotton, on which small geometrical shapes, crosses, individual letters have apparently been distributed haphazardly. The dirty ground, frayed edge and title lead us to see the picture like an old carpet on which mysterious signs recall past ages and cultures. If the picture is turned ninety degrees to the left, a perfectly logical architectonic structure becomes visible. The writing in the top left-hand corner indicates that Klee originally planned the picture to be hung upright and later turned it round. It was not unusual for him to make such changes at a later date. Although no direct connection is apparent, *Teppich der Erinnerung* can certainly be regarded as a fruit of the trip to Tunisia.

Klee went to Tunisia – and there at last found the access to colour for which he had been yearning for so long – at a time which, for his closest friends, meant the end of their œuvre. A little more than three months after Klee's return home, Germany declared war on Russia and marched into France. Franz Marc and August Macke volun-

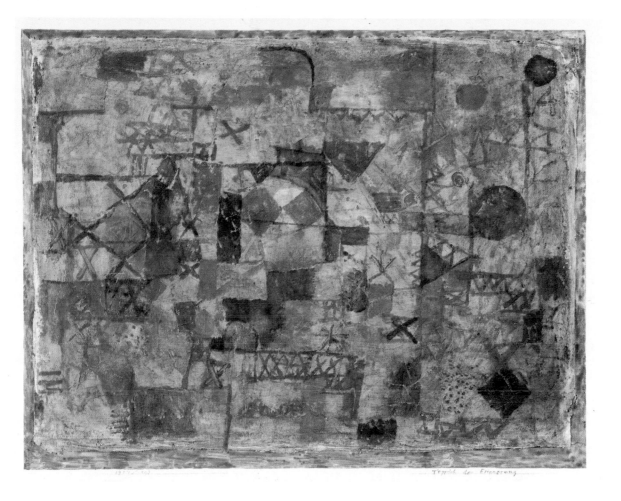

teered to defend the fatherland. Marc, unlike Macke, still had enough time to rethink his patriotic idealism; still, both men were killed in the war. Klee stayed in Munich and painted. And later, from 1916, after he had been called up, he still had the opportunity to paint. He went on developing, participating in exhibitions and, at last, selling his pictures.

Carpet of Memory, 1914, 193
Teppich der Erinnerung
Oil over linen with chalk and oil ground, mounted on cardboard, 40.2 × 51.8 cm
Paul Klee Foundation, Kunstmuseum, Berne

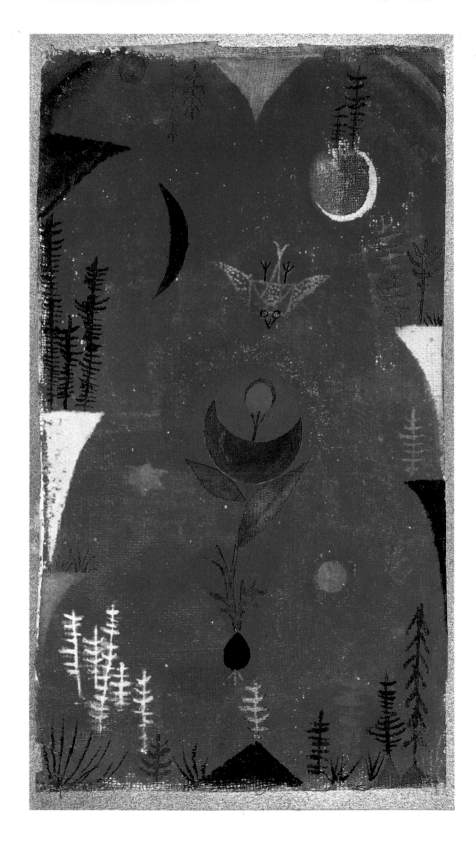

The First World War

Paul Klee's first big sales success was in 1917, during the war. At that time he was either painting illustrative pictures containing figures or giving them titles identifiable in literature. He seemed little affected by the war. In 1915 he wrote in his diary, "I have long had this war in me. That is why, inwardly, it is none of my concern." Many writers on Klee have assumed that this meant that Klee was little moved by world events, without taking into account the political views of this withdrawn artist, whatever they may have been.[19]

And yet, in his letter of 9 December 1902, Klee had written to Lily that he was "generally revolutionary". Philipp Lotmar, a law professor from Berne and the father of his former school mate and close friend Fritz Lotmar, had introduced him to the principles of socialism. Oscar Wilde's essay on 'The Soul of Man Under Socialism', which Lotmar had given him to read, impressed him so much that in a letter to Lily he wrote a detailed summary of the contents, adding his own thoughts on the subject. Although he was sceptical about the realization of socialism, he nevertheless wrote: "If socialism wants to create a suitable milieu for every talent and can do so, then I, too, am a socialist. But I lack belief, as in most things. I would never be against socialism, however, because it is the only decent movement."[20]

The revolutionary movement in Russia, which was suppressed with much bloodshed in January 1905, had occasioned Klee to read Wilde's essay and had given rise to the discussion in the Lotmars' home. The string quartet to which Klee and Lotmar belonged participated in a benefit evening for the surviving relatives of the victims of St. Petersburg. In the same year Klee was concerned, artistically, with the revolution. To Lily, he explained his *Greiser Phoenix* (*Aged Phoenix,* p. 13), the last etching but one of his *Inventionen,* as follows: "I have an allegory of inadequacy as a rising phoenix; pictorially very interesting. For example, you just have to imagine there has just been a revolution, inadequacy has been burned, and now there it is, rejuvenated, rising out of its own ashes. That is what I believe . . ."[21] He did, however, modify this interpretation after he finished the picture. The rejuvenated Phoenix became an aged one and (like all the *Inventionen*) was accompanied by an explanation: *Greiser Phoenix als Symbol der Unzulänglichkeit menschlicher Dinge – auch der höchsten – in kritischen Zeiten* (*Aged Phoenix as a Symbol of the Inadequacy of Human Things – Even the Highest – in Times of*

Death on the Battlefield, 1914, 172
Tod auf dem Schlachtfeld
Pen, 9 × 17.5 cm
Felix Klee Collection, Berne

Flower Myth, 1918, 82
Blumenmythos
Watercolour on shirting with chalk ground, mounted on newspaper, mounted on cardboard, with silver-bronze frame, 29 × 15.8 cm
Sprengel Museum, Hanover

Death for the Idea, 1915, 1
Der Tod für die Idee
Pen and ink lithograph, 16.2 × 8.5 cm
Sprengel Museum, Hanover

Crisis). Werckmeister sees in the deformed figure with only one breast and one foot and almost completely devoid of feathers a personification of the abortive revolution. With the skull of a dead phoenix crowning a staff in its hand, it is displaying the proof that revolutions cannot succeed.[22] Though it might not always be apparent on first sight, Klee did sometimes use his art to comment on the events of the age. In August 1914, the "withdrawn" artist wrote both in his list of works and his diary, "Beginning of World War". His correspondence with Kandinsky and others shows that he certainly thought about the war and was not greatly opposed to it. Like many people, he expected a quick German victory and hoped that the "national upswing . . . will again bring us the means (courage and money from patrons and publishers) withheld by the pressure of recent years."[23]

Klee changed his mind about the war after Macke's death. His criticism is expressed in a letter to Marc. Soon after being called up, Marc had begun writing essays in which he spoke of a sick Europe that could only be healed by a war – by a blood sacrifice made by the community of nations. He had the vision that after a quick and victorious end of the war, Germany would become dominant in Europe. Maria Marc gave these letters to Klee to read before she took steps to have them published. In one of his first letters to Marc at the front, Klee mentioned having read the essays: "The essays given me to read by your wife make it clear how freely your mind has adapted to the outrageous changes. We are really the ones whose delicate hopes, particularly now, have been hard hit. But you have replaced the loss with the boldest of expectations. And how few of us Germans there are – and even so?! And now we have had to lose August Macke . . ."[24]

At this time Klee was also giving the subject of war artistic treatment. There are twelve titles listed among his works for the period between August and December 1914, including *Tod auf dem Schlachtfeld (Death on the Battlefield*, p. 31). But Klee's radically subjective art, both abstract and expressive, was not a persuasive platform for his views on war. His aim of introducing his art to as wide a public as possible induced him to sell some of his lithographs to the newly established journal *Zeit-Echo. Ein Kriegs-Tagebuch für Künstler (Echo of the Times. A War Diary for Artists)*. The drawing *Tod für die Idee (Death for the Idea*, p. 32) was published next to a poem by Georg Trakl (1887–1914) and referred to it. Klee was not illustrating the poem but alluding to Trakl's suicide.

Trakl had been one of the many artists who had gone to war with great enthusiasm. And he was one of the first who could not stand the reality of war. He had a nervous breakdown and, in the military hospital in Krakow, committed suicide with an overdose of cocaine. Klee presumably knew about this and wanted to draw attention to it.

But the poem and picture were so placed in *Zeit-Echo*, which boasted of being open in all directions, that Klee inadvertently found himself on the side of artists and writers who had been of liberal convictions, but were now chiming in with the current enthusiasm for the war. This ran counter to his own intentions and led him to distance himself from the whole thing at the beginning of 1915 with the fol-

Föhn Wind: In Franz Marc's Garden,
1915, 102
Föhn im Marc'schen Garten
Watercolour, mounted on cardboard,
20 × 15 cm
Städtische Galerie im Lenbachhaus, Munich

1915 102

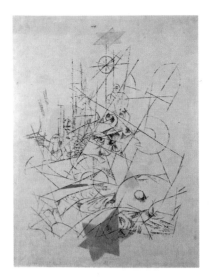

Destruction and Hope, 1916, 55
Zerstörung und Hoffnung
Lithograph and watercolour, 52.5 × 39.8 cm
Städtische Galerie im Lenbachhaus, Munich

lowing remarks (which however were probably not given this final form until he edited his diaries in 1921): "You leave the here and now and instead cross over to a yonder that can be total affirmation. Abstraction. The cool romanticism of this style without pathos is unheard of. The more terrible this world (like today's, for example), the more abstract our art, whereas a happy world produces art from the here and now." (Diaries, 951)

The last sentence in particular referred to a text that had been extremely popular in the heyday of Der Blaue Reiter – Wilhelm Worringer's "Abstraktion und Einfühlung" (Abstraction and Empathy). It was written in 1907 as a dissertation, published in book form in 1908 and was already into its third edition by 1910. Worringer's view, which Klee was repeating in his own words, was supported by many people before the war. Thus Klee's view referred to an avant-garde concept of art. But the success he had hoped to have with the public did not materialize. Even the few collectors who knew his works in those days preferred his Tunisian watercolours and landscapes such as *Föhn im Marc'schen Garten (Föhn Wind: In Franz Marc's Garden,* p. 33). They were not prepared to take the path to abstraction such as was manifested in *Grünes X links oben (Green X Upper Left).*

In February 1916 Klee, who had already expected to be called up in August 1914, was graded as suitable for war service after all. He received his call-up papers on the same day that he learned of Franz Marc's death. He felt he was taking his friend's place, rather like a changing of the guard. He was given basic training in Landshut, and then, on 20 July, moved to the Second Reserve Infantry Regiment in

Quarry at Ostermundingen, 1915, 213
Steinbruch Ostermundingen
Watercolour over pencil on paper, mounted on
cardboard, 20.2 × 24.6 cm
Paul Klee Foundation, Kunstmuseum, Berne

Cosmic Composition, 1919, 165
Kosmische Komposition
Oil on wood, 48 × 41 cm
Kunstsammlung Nordrhein-Westfalen,
Düsseldorf

Munich. For him, this meant direct preparations for active service at the front. But in August he was unexpectedly sent to the Airforce Replacement Unit in Schleissheim. He will probably have discovered shortly afterwards that, with the help of influential friends, his father had done everything in his power to get him exempted from service at the front. These friends knew that, after the death of Franz Marc, Albert Weissgerber (1878–1915) and other artists, the Bavarian king had ordered that Munich artists be spared. They informed the proper authorities of Klee's profession. Thus it was not least due to his friend Marc that Klee did not have to go to the front. Instead, as befitted his profession, he painted aircraft.

On 16 January 1917 he was again transferred, this time to the flying school in Gersthofen, where he worked as a clerk to the treasurer. He stayed there until the end of the war. Klee did not have to interrupt his painting during his entire war service. He had already managed to take a private room while in Landshut and did so again in Schleissheim and Gersthofen, and there he withdrew after doing his day's

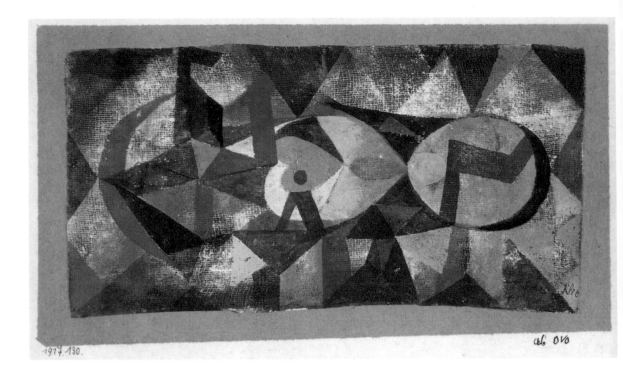

Ab ovo, 1917, 130
Watercolour on gauze and paper with chalk
ground, 14.9 × 26.6 cm
Paul Klee Foundation, Kunstmuseum, Berne

work and painted. And in addition, Lily and Felix were able to visit him when he did not have the weekend off.

By the end of 1915, Klee had already given up working the subject of war into his pictures, even in a very abstract form. For his first exhibition in Herwarth Walden's Der Sturm gallery in March 1916, he gave his abstract watercolours new, unambiguously thematic names. Walden sold some of the pictures and even asked Klee to provide more. Klee was working for the art market. Paradoxically, his first success with his paintings, which he wanted to be seen as a resolute rejection of war, came at the very moment he was conscripted.

Walden had written an obituary of Franz Marc even while Klee's exhibition in the Sturm gallery was still in progress, and his characterization of the artist had seemed to apply more to Klee. Klee's sense that he was replacing Marc on the battlefield now confronted him in the field of art. For his next exhibition in February 1917, Klee mainly sent Walden watercolours he had painted in 1916, either depicting figures that were recognizable as such or with poetic-sounding titles. Klee sold a huge number of pictures at this exhibition and he did not enjoy such a success again until the end of the war. Art critics acclaimed him as the most important German artist since Marc's death.

Klee's extraordinary success was based on two factors. Firstly, the painter was beginning to be influenced by the public in his art. The positive reactions to his change in style in 1916 spurred him to carry on working in this direction. Secondly, economic reasons played an important part in it. Profits from the growing production of weapons for the war increased the buying power of the well-to-do. They

had to invest their capital to prevent it from losing value. Modern art benefitted from this fact.

It was not only Klee who was able to sell a lot in 1917. Werckmeister sees in this year "the point at which modern art linked hands with 'bourgeois' culture, to which before the war it had been a challenge, to form a mutual ideology. The financial and economic conditions for this process can be pinpointed to that year. Objectively, they contradict the freedom Klee had laid claim to in his concept of abstraction in 1915. As it is, Klee indeed owed his career as an artist to the war he believed he had turned his back on – simply by the fact that he had turned his back on it."[25]

A tendency that was already becoming apparent in *Im Stil von Kairouan, ins Gemässigte übertragen* (*In the Style of Kairouan, Transferred to the Moderate*, p. 27) and *Mit dem braunen △ (With the Brown △),* both of which he painted from memory, is also seen in *Steinbruch Ostermundingen* (*Quarry at Ostermundingen*, p. 34). Klee painted this watercolour in 1915 while spending his last summer during the war in Berne. In spite of its title, it is not a landscape. Abstract areas of colour have been joined together to form projecting cubes. Is this a view of the sides of a quarry or an abstract picture? Both interpretations are possible.

In 1916, after his abstract phase of 1915, Lily sent him some

With the Eagle, 1918, 85
Mit dem Adler
Watercolour on red foundation on paper and chalk ground, with backing of shiny green paper, mounted on cardboard, 17.3 × 25.6 cm
Paul Klee Foundation, Kunstmuseum, Berne

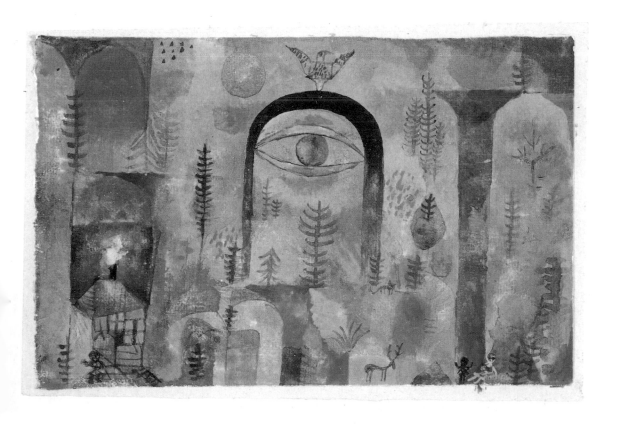

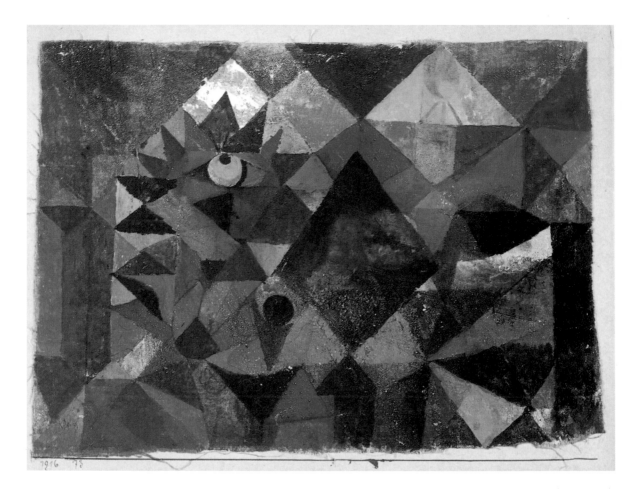

Cacodemonic, 1916, 73
Kakendämonisch
Watercolour on cotton with plaster ground,
mounted on cardboard, 18.5 × 25.5 cm
Paul Klee Foundation, Kunstmuseum, Berne

Once Emerged from the Grey of Night . . ., 1918, 17
Einst dem Grau der Nacht enttaucht . . .
Watercolour and pen and ink on paper,
22.6 × 15.8 cm
Paul Klee Foundation, Kunstmuseum, Berne

Bahn

Einst dem Grau der Nacht enttaucht / Dann schwer und teuer / und stark vom Feuer /
Abends voll von Gott und gebeugt / Nun ätherlings' vom Blau umschauert, / entschwebt
— über Firnen, zu klugen Gestirnen.

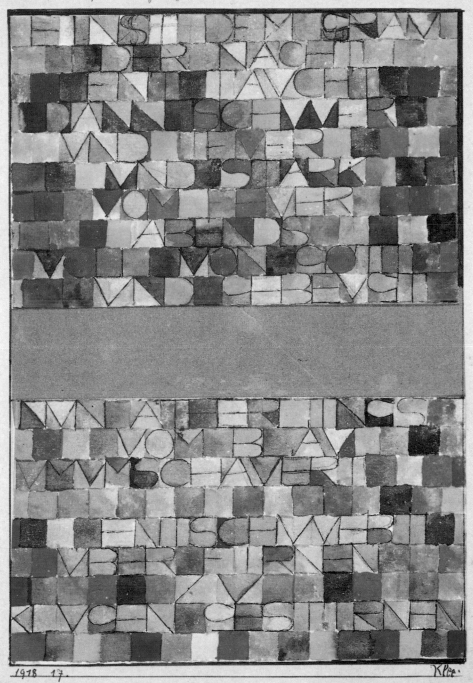

1918 17. Klee.

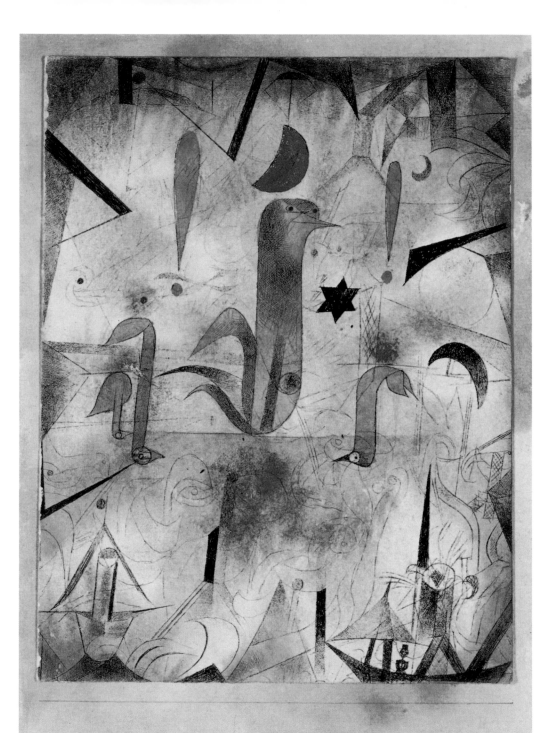

1917. 108. *Warnung der Schiffe*

Chinese poems, which he put into pictures. He actually planned a larger cycle of such "poetry pictures", but he did not get beyond a few individual experiments. In 1918 he painted *Einst dem Grau der Nacht enttaucht* (*Once Emerged from the Grey of Night*, p. 39), a poem transcribed as a picture. Its source is unknown and it is assumed that Klee himself wrote it:

"Einst dem Grau der Nacht enttaucht
Dann schwer und teuer
und stark vom Feuer
Abends voll von Gott und gebeugt.
Nun ätherlings vom Blau umschauert,
entschwebt über Firnen,
zu klugen Gestirnen."[26]

(Roughly:)

"Once emerged from the grey of night
Then heavy and dear
and strong from the fire
In the evening full of God and bent.
Now ethereally surrounded by shuddering blue
floating away over firn
to clever stars."

The structure of the picture is strictly geometrical. Letters appear in small squares of differing colour. The picture has been cut between the first and second verses and a strip of silver paper inserted. The poem can again be read on the cardboard on which the watercolour has been mounted. The colours are clear and brilliant, similar to *Kakendämonisch* (*Cacodemonic,* p. 38) or *Ab ovo* (p. 36). Here, Klee was not being influenced by Robert Delaunay in his use of colours, but by Franz Marc. Again we see Klee's idea of "changing the guard", his obligation to carry on where Marc had left off, an idea that met with the approval of others, particularly his art dealer Herwarth Walden, even if the contents of the pictures by the two painters Klee and Marc scarcely have anything in common.

The idea of flying, which had been in Klee's mind for a long time, was deepened by being stationed with airmen. He had already done *Der Held mit dem Flügel* (*The Hero with the Wing*, p. 6) as the third of his *Inventionen* in 1905 and he had marked the etching as follows: *The Hero with the Wing. Endowed by nature with one wing, he got the idea that he was predestined to fly, and this was his downfall.* In his diary he wrote, "This person, who, unlike divine beings, was born with only one angelic wing, makes ceaseless efforts to fly. The fact that in doing so he breaks his arms and legs does not prevent him from remaining loyal to his idea of flying." (Diaries, 585) He frequently dealt with his vision of flying in his diary. In 1915, still trying to disassociate himself from the war, he wrote, "To work my way out of my ruins I had to fly. And I flew." (Diaries, 952)

From 1917 onwards, he had plenty of opportunity in Gerstenhofen to observe aircraft in flight – and indeed crashing – at close quarters. It was then that birds started appearing in his pictures – birds nose-diving from above like paper aeroplanes, such as in *Blumen-*

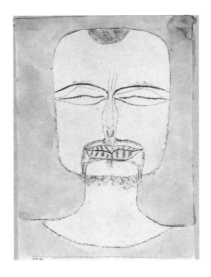

Absorption, 1919, 113
Versunkenheit
Lithograph with watercolour additions,
25.6 × 18 cm
Felix Klee Collection, Berne

Warning of the Ships, 1917, 108
Warnung der Schiffe
Pen and watercolour on paper, mounted on cardboard, 24.2 × 15.6 cm
Graphische Sammlung, Staatsgalerie, Stuttgart

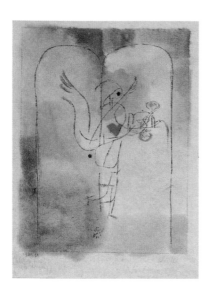

*A Genius Serves a Small Breakfast (An Angel
Brings What is Desired)*, 1920, 91
Ein Genius serviert ein kleines Frühstück
(Engel bringt das Gewünschte)
Lithograph, with watercolour additions,
19.8 × 14.6 cm
Sprengel Museum, Hanover

Head with German Moustache, 1920, 22
Kopf mit deutscher Barttracht
Oil with pen and ink on paper, mounted on
wood, 32.5 × 28.5 cm
Kunstsammlung Nordrhein-Westfalen,
Düsseldorf

mythos (Flower Myth, 1918 – p. 30). Apart from the direct association
with Gerstenhofen, which is expressed even better in the drawing
Vogel-Flugzeuge (Bird Aircraft), this picture is an especially good il-
lustration of Klee's view of flying, childhood and sexuality, which he
had already written about in his diary in 1906: "Dream. I flew home,
where the beginning is. It started with brooding and finger-chewing.
Then I tasted or smelled something. If a delegation were to come to
me and bow down solemnly before the artist, gratefully pointing to
his work, I would only be a little surprised. After all, I was where the
beginning is. I was with my esteemed Madame Monad, which is tanta-
mount to being fertile." (Diaries, 748) The last two sentences are, in-
cidentally, the subject dealt with in the watercolour *Ab ovo* (p. 36), in
which the egg and semen merge to become the primordial cell.

There is another picture that Klee painted in Gerstenhofen, one
in which the little paper aeroplane bird neither flies nor crashes: *Mit
dem Adler (With the Eagle*, p. 37) is dominated by warm shades of
red. Small, childishly drawn trees, houses and animals remind us of a
fairy tale. Above the huge eye in the centre of the picture there is a
big arch on which a tiny eagle with outstretched wings is balancing. It
is about to take off over the landscape and the watching eye. Werck-
meister sees in this eagle "Klee's allegory of the artist soaring above
the ruins of war".[27] Significantly, Klee did not put this picture up for
sale, but kept it for himself. Neither did he show it at any of his ex-
hibitions, which otherwise he often did with pictures he did not want
to sell, but regarded as being programmatic.

The revolutionary government of 7 November 1918 was pro-
claimed in Munich even before the armistice on 11 November. Klee
had already written to Lily on 30 October about his fears of an im-
pending revolution. In December he asked the revolutionary council
to discharge him from service and was demobilized. As the secretary
of the New Munich Secession, he discovered that the new govern-
ment supported modern art. In April 1919 Klee was invited to join the
Executive Committee of Revolutionary Artists and enthusiastically ac-
cepted. But he never had a chance to work on the committee. The rev-
olutionary government was toppled and Munich occupied by Frei-
korps troops. It was at this time that Klee created his coloured
lithograph entitled *Versunkenheit (Absorption*, p. 41), which impress-
ively represents the artist's renewed withdrawal from the world.

In a letter to Alfred Kubin dated 12 May 1919, which, however,
he did not post until 10 June after having taken the precaution of leav-
ing Munich for Switzerland, he summarized his experiences of the
previous months. "Right from the beginning, it seemed that this com-
munist republic would be short-lived, but it did give us the oppor-
tunity of checking our subjective in such a community. It was not
without a positive result. Of course, exaggerated, individualist art is
not suitable for the general public – it is a capitalist luxury. But I
think we are more than just curiosities for wealthy snobs. And all that
in us which in some way or the other is striving for eternity would be
more likely to be encouraged in a communist community. Our
example would be fruitful and influential across a broad spectrum, if

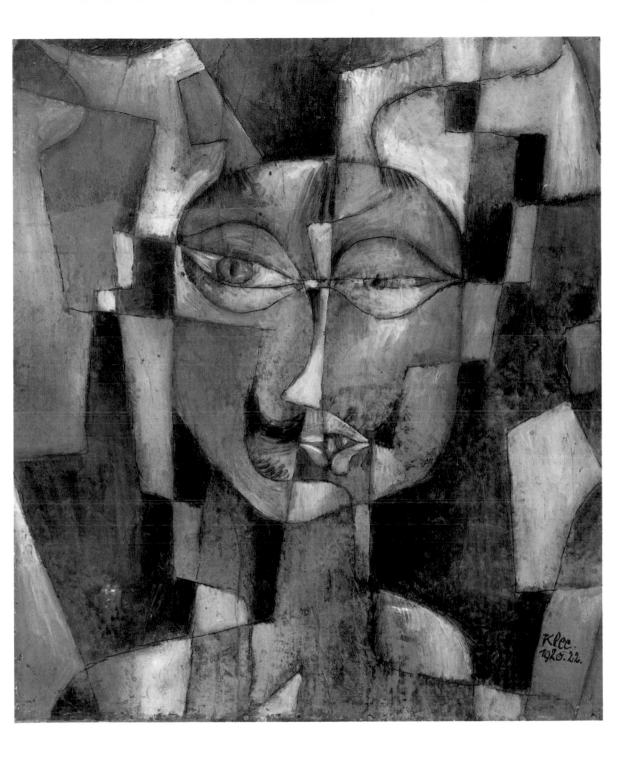

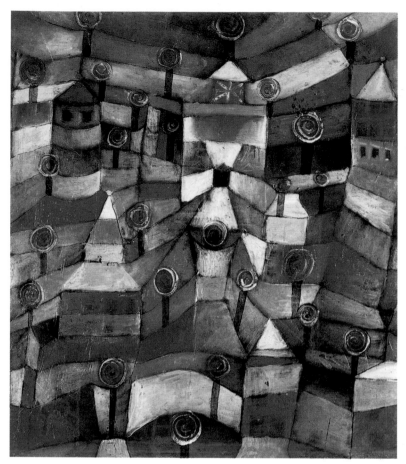

Rose Garden, 1920, 44
Rosengarten
Oil on cardboard, 49 × 42.5 cm
Städtische Galerie im Lenbachhaus, Munich

channelled differently . . . This new art would grasp craftsmanship and bring forth a great new flowering. For there would no longer be academies, but only art schools for craftsmen."[28]

It is possible that by then Klee already knew there were plans afoot to offer him a job in one such "art school for craftsmen". A year later he was appointed to the Staatliches Bauhaus in Weimar. In 1919 it looked as if Klee would be offered a teaching post at the art academy in Stuttgart, but it soon became clear that nothing would come of this hope. By now, Klee – unlike many other artists who had joined the revolution – had sold so many pictures that he no longer felt able to act as his own agent and manager. He signed an exclusive contract with Hans Goltz, who had helped him with supportive purchases in 1918. In 1920 Goltz organized a retrospective comprising 326 works. Two monographs were published, based on extracts from his diary, which Klee had given the authors. This was the breakthrough.

Villa R, 1919, 153
Oil on cardboard, 26.5 × 22 cm
Kunstmuseum, Basle

Yet although the contract with Goltz guaranteed him a minimum annual income, Klee felt it was too risky for him to depend entirely on selling his pictures. The fluctuations the art market was subject to were too great. This in itself was reason enough for him to accept the offer from the Staatliches Bauhaus to go to Weimar.

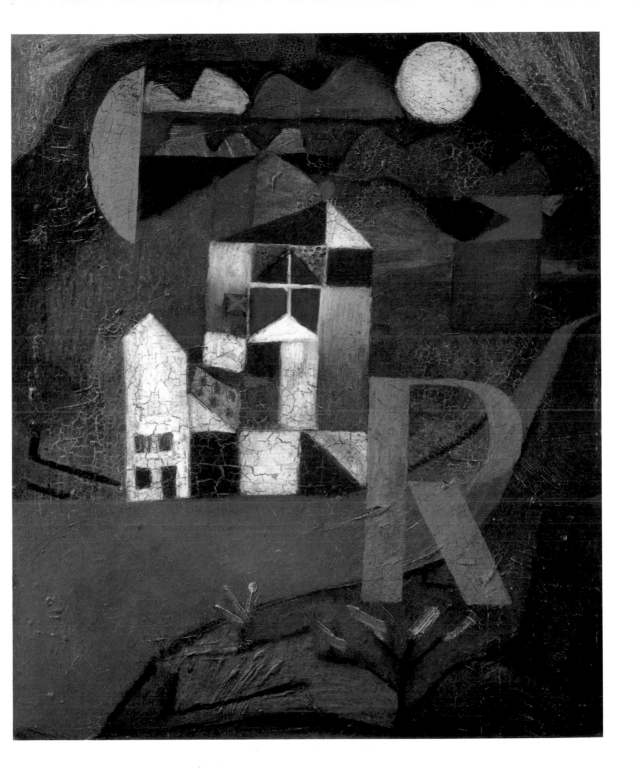

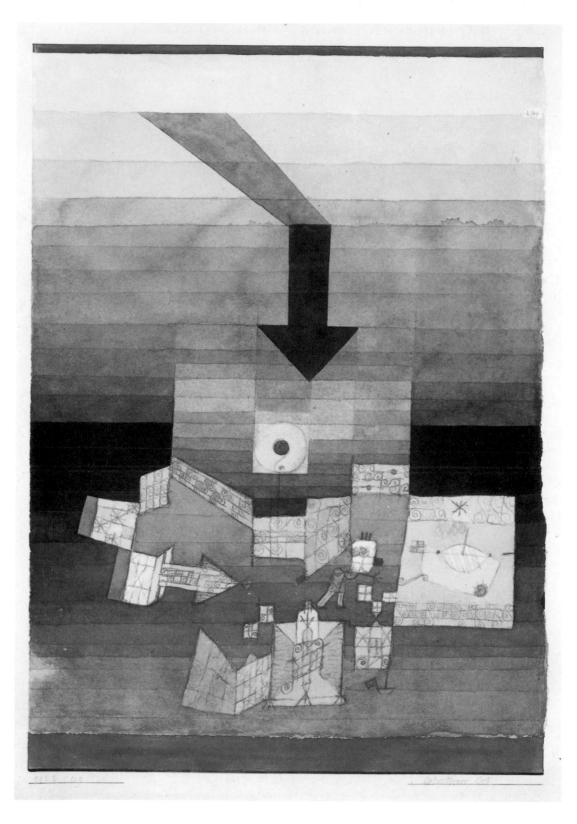

Bauhaus and Düsseldorf

"Dear Mr. Klee, it was with great joy that we unanimously sent you a telegram today. Now that our budget has been granted, we are in a position to invite another master to our circle. There was no question whom we should choose. All year I have been waiting for the moment when I could send you this invitation. I expect you already know roughly what we have started here and have no fundamental misgivings. The students are radiant at the thought that you could come. So you see, everyone is expecting you with affection. That is why we are all awaiting a quick 'Yes'. It would probably be the best thing for you to come and see us as soon as possible so that we can discuss everything. The economic position is as follows: free studio and a salary of 16,500 Marks. Please let us know soon if you will be coming – it would be nice if you were. Respectfully yours, Walter Gropius. Weimar, 29. 10. 1920, Bauhaus."[29]

The Staatliches Bauhaus had been established in Weimar in April 1919 under the direction of architect Walter Gropius. After the 1918 November revolution in Berlin, Gropius had been a member of the Work Council for Art. With the help of the Social Democratic education minister, he was able to put some of the ideas developed there into practice at the new institution. The Bauhaus united the former College of Fine Arts and what was left of the School of Arts and Crafts. The idea was that the various branches of art should no longer continue to exist autonomously, isolated from one another and from the craftsman's real world, but should lead the way to a "reunification of all the disciplines of the arts and crafts – sculpture, painting, handicrafts and craftsmanship".[30] As had already been the case with Art Nouveau, the idea of a universal artwork *(Gesamtkunstwerk)* was again adopted. It was a return to the mediaeval idea of the unity of art and craftsmanship. On the other hand, however, mediaeval means of production were not glorified, as William Morris (1834–1896) had done some fifty years previously in England; instead, the aim was for art and industry to work hand in hand.

Defining the aims and principles of the Bauhaus, Gropius wrote: "Art comes into being above all methods. Art itself cannot be taught, but craftsmanship can. Architects, painters, sculptors are all craftsmen in the original sense of the word. Thus it is a fundamental requirement of all artistic creativity that every student undergo a thorough training in the workshops of all branches of the crafts."[31] The Bauhaus teach-

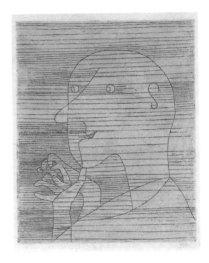

Old Man Calculating, 1929, S 9 (99)
Rechnender Greis
Etching on copper, 29.9 × 23.7 cm
Sprengel Museum, Hanover

Stricken Place, 1922, 109
Betroffener Ort
Watercolour, pen and India ink drawing over pencil, on paper mounted on cardboard, 32.8 × 23.1 cm
Paul Klee Foundation, Kunstmuseum, Berne

ers and students deliberately called themselves "masters, journeymen and apprentices". At the end of their training, students could take a journeyman's or master craftsman's examination. The workshops were led by two people, the Form Master, such as Paul Klee, and a master craftsman. The aim was to drop this division once there were enough students at the Bauhaus. Gropius saw no fundamental difference between art and craftsmanship. Instead, he saw art as the next stage on from craftsmanship – an unplanned development for which, however, craftsmanship was essential if it was to be put into practice.

At the beginning of their training at the Bauhaus, all apprentices were required to attend a preliminary or elementary course, which was also a kind of trial period. This was followed by training in the workshops – metal, typography, pottery, weaving, sculpting, stagecraft. Klee was the Form Master in the book binding workshop until it was discontinued in 1922. After that, together with Wassily Kandinsky, who was appointed to the Bauhaus in 1922, he was in charge of the workshops for stained glass and mural painting.

From the start, the Bauhaus had to defend itself against attacks primarily from conservative Nazi circles. In 1924, the now right-wing Thuringian government revoked its contracts with the Bauhaus and its Masters. After difficult negotiations with several cities, the municipal parliament in Dessau agreed to take over the Bauhaus. For a year students and teachers had to put up with makeshift housing. Then, in 1926, regular teaching was resumed in a building designed by Gropius. Gropius had also designed houses for the Masters. These were finished by the summer of 1926, and from then on Klee and Kandinsky again lived next door to each other.

But again in Dessau there were conflicts with the city authorities. In 1928 Gropius left the Bauhaus. His successor was Hannes Meyer (1889–1954), who by this time had already spent a year working in the Bauhaus. Meyer's aim was the unity of workshop work, free art and science. He did all he could to prevent a "Bauhaus style" from developing.

The distinction between form masters and craftsmen was abandoned even while Gropius was still in Dessau. By now a generation of students had become able to take over the workshops. At the same time, Klee and Kandinsky managed to get their way about setting up "free painting classes", which, however, were of no importance for the school as a whole. The ideas that had once been fundamental to the Bauhaus idea lost their binding character.

Meyer tried to use extreme functionalism to offset this tendency. He encouraged applied design with a social function – such as the further development of wall paper, industrial textiles, lamps and furniture. His policy did not always meet with approval. Those who did not approve brought pressure to bear for Hannes Meyer to be dismissed in 1930 without notice, for bringing politics into the Bauhaus and making it into a playground for communist activities. He was followed by Ludwig Mies van der Rohe (1886–1969), who tried to move the Bauhaus towards crafts and scholarship, pure and simple. He hoped that by doing so he would be able to keep political struggles at

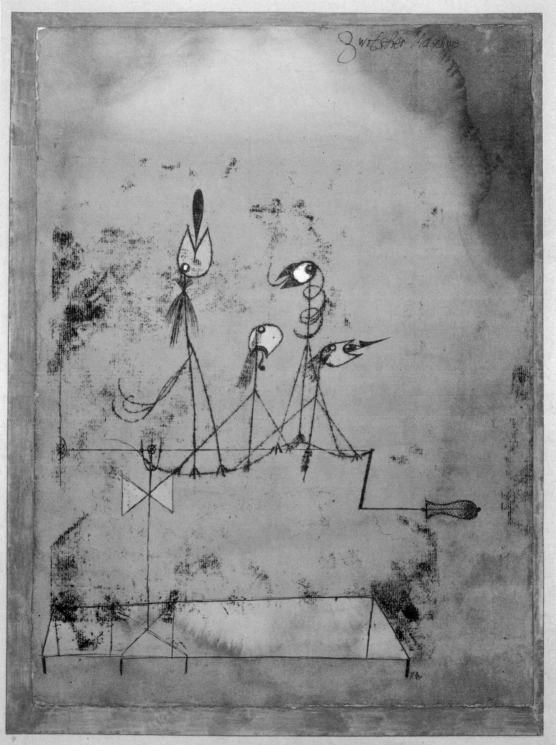

Zwitscher Maschine

1022/151 Die Zwitscher-Maschine

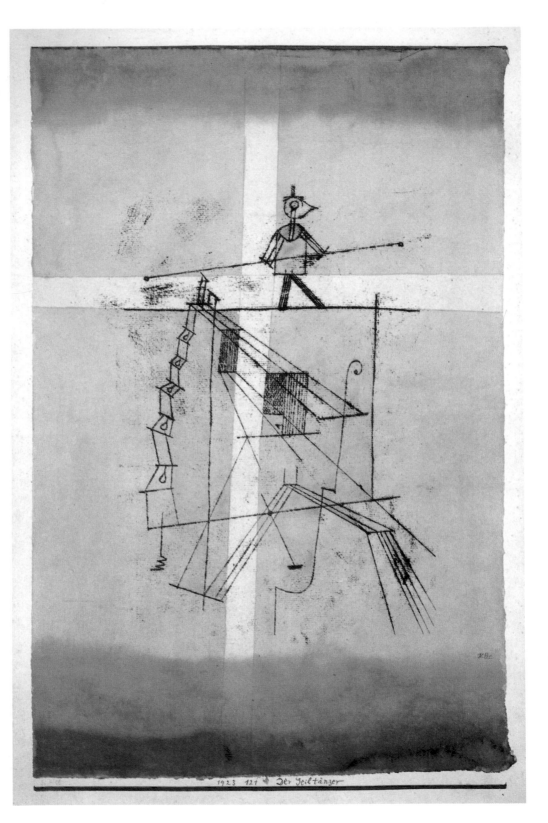

1923 121 Der Seiltänzer

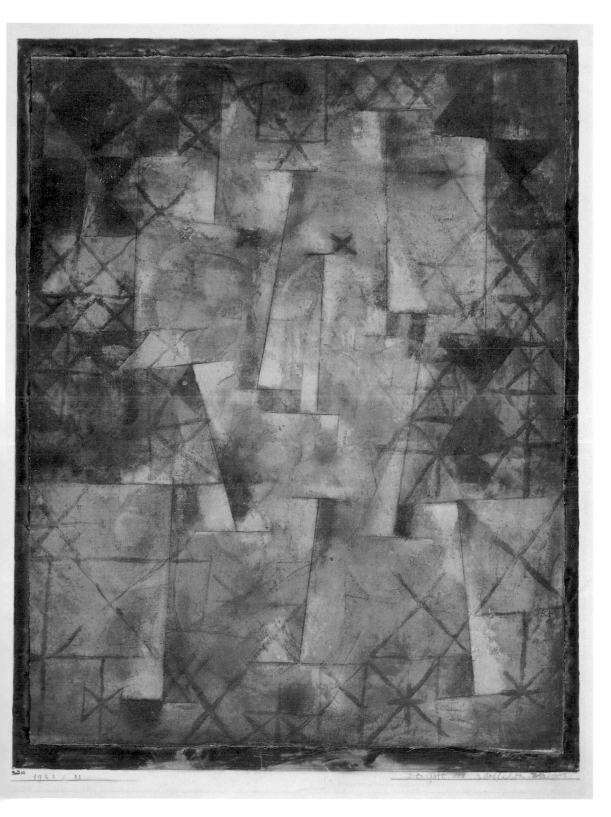

Woodland Berry, 1921, 92
Waldbeere
Watercolour on paper, mounted on cardboard,
32 × 25.1 cm
Städtische Galerie im Lenbachhaus, Munich

Harmony of Rectangles in Red, Yellow, Blue,
White and Black, 1923, 238
Harmonie aus Vierecken mit Rot, Gelb, Blau,
Weiss und Schwarz
Oil on cardboard with black ground,
69.7 × 50.6 cm. Original frame, painted:
83.4 × 64.5 cm
Paul Klee Foundation, Kunstmuseum, Berne

bay. But in 1932, a majority in the Dessau city parliament decided to dissolve the Bauhaus. Mies van der Rohe succeeded in moving it to Berlin as a privately run institution, where it managed to keep going for a year before it was closed by the Nazis. The teachers and students, a large number of whom emigrated, spread the idea of the Bauhaus abroad. The preliminary course in particular was – and still is – imitated by many institutions. Attempts at setting up a new Bauhaus have never lasted long. The architecture and design of what used to be the Bauhaus remain influential even today.

Klee's appointment was a perfectly logical cultural and political decision. After the November revolution in Munich and after dilly-dallying to begin with, he had avowed his left-wing politics and had also been accepted by the political left. Painters already working at the Bauhaus knew Klee or least his art. They were all adherents of the type of modern art shown at the Sturm gallery in Berlin and they had all been sponsored by Herwarth Walden. There was a large common denominator. This changed when Constructivists, such as László Moholy-Nagy (1895–1946), came to teach at the Bauhaus.

Klee took up his appointment in Weimar in January 1921. He commuted between Munich and Weimar until September, when his family was able to join him. Felix was not quite fourteen when he became the youngest of the Bauhaus students. In April, after three months spent getting adjusted, Klee started his theoretical tuition, in which he showed his own pictures and analysed them. But it was not long before he gave up this form of teaching. In the winter term 1921 he announced a series of lectures on "Visual Form", which he carefully worked out in detail. (They were made available in 1979 in book form.) Here he took up ideas formulated by Johannes Itten (1888–1967) in the preliminary course. Klee identified himself with the Bauhaus ideas, especially during the first years. During a quarrel between Gropius and Itten on basic principles, which ended with Itten's dismissal in October 1922 and his final departure in 1923, Klee made a statement in December 1921 showing that he welcomed the opportunity for debate: "I welcome the fact that there are so many conflicting forces at work in our Bauhaus. I also approve of these forces competing one with the other if the result is achievement. It is always a good test for any force to meet with obstacles, as long as those obstacles remain objective. Any evaluation is always limited by subjectivity, and a negative judgement on the achievement of any one person cannot apply to the entire body. These is nothing right or wrong about the sum of these forces; instead, it lives and develops as a result of their interaction, in the same way that, in the world as a whole, good and evil in the end combine and become productive."[32]

In 1924, at an exhibition of his works at the Art Society in Jena, Klee held a speech on his painting which ended with a public acknowledgement of the Bauhaus. In this speech, he refered to remarks made by Gropius. "I sometimes dream of a huge work covering the entire field of elementary and representative art, covering everything to do with content and style. This will surely remain a dream . . . Nothing can be precipitated. It must grow, this work, grow upwards,

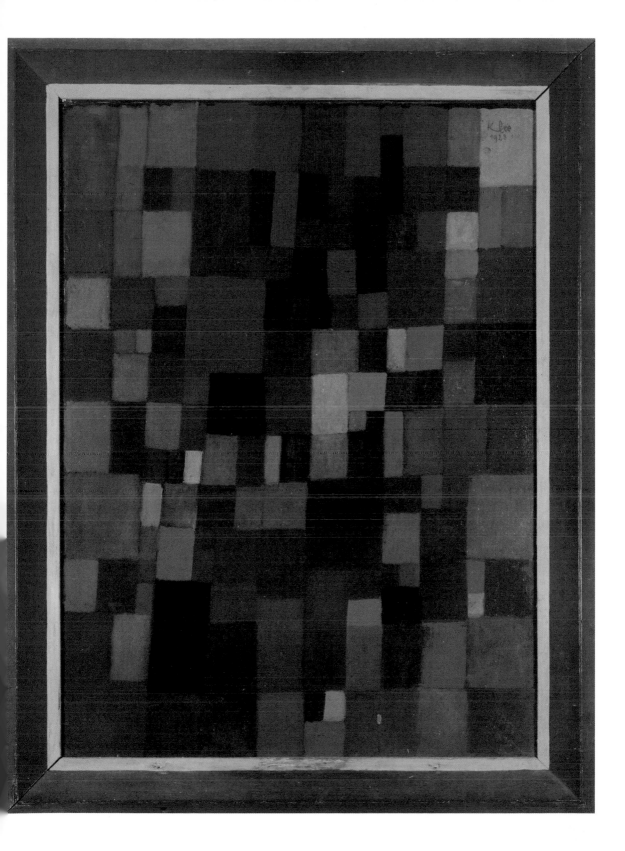

monsieur Pearly Pig, 1925, W 3 (223)
monsieur Perlenschwein
Spray technique with stencil in watercolour, on
Japanese etching paper, mounted on card-
board, 51.5 × 35.5 cm
Kunstsammlung Nordrhein-Westfalen,
Düsseldorf

and then when it is time for it, all the better! We still have to search.
We have found parts of it, but not the whole. We still have not got that
final energy, for we are not supported by a people. But we are looking
for a people – we started doing so at the Staatliches Bauhaus. We
started off there with a community and we gave it all we had. We can-
not do more."[33]

This 'devotion' brought Klee into conflict with his own artistic
work. In 1926, when he was already teaching in Dessau but his family
was still in Weimar, he would only hold classes every fortnight, which
annoyed colleagues and students alike. In 1927, he divided his teach-
ing into a theoretical and a practical section. The students were ex-
pected to cope with the practical part by themselves. And Klee did not
turn up for his classes – without, however, notifying his colleagues or
the head of the school. He simply disappeared to Switzerland and
France. While he was there, a telegram and two letters reached him in
which he was told to return immediately. He replied on 22 September
– politely but firmly: "First and foremost I am a working artist and as
a teacher have taken the risk of dutifully accepting a task that is diffi-
cult, in that this position is a burden that can only be balanced with
my productive activities under certain conditions. These conditions
are that my teaching activities are themselves *productive* and that re-
creation in the form of holidays is made possible . . . I will definitely
be returning on 3 October . . ."[34] He thus gave himself another fort-
night; he did not follow the call of his colleagues, but continued to
pursue his original plans.

The reason for Klee's lack of consideration towards his col-
leagues lay not in the fact that he no longer supported the aims of the
Bauhaus. He was simply no longer able to reconcile them with his
own aims. This is made clear in some of the letters he wrote to Lily in
1928: "Demands both from within and without are so great that I
would lose all feeling for time . . . My bad conscience faithfully fol-
lows me; there's always something nagging at me – art, school, the
human side of life . . ."[35] And a year later he wrote to his son and for-
mer Bauhaus student: "The Bauhaus will never calm down, otherwise
it would cease to be the Bauhaus, and if you are part of it, you have to
work with it, even if you don't want to."[36]

Klee did not want to. He started negotiations with other acad-
emies and in 1930 was invited to go to Düsseldorf. Dessau then of-
fered him better working conditions, including above all less work.
He turned the offer down, however, saying that it would not be com-
patible with the ideas of the Bauhaus if his work were to be reduced.
In a letter to Lily on 24 June 1930 he summed up the ten years he had
spent working in Weimar and Dessau: "Work at the Bauhaus is easy if
you don't feel duty-bound as a painter to produce something. It looks
so easy at the moment. Since this condition will pass, I can live quite
well with it. The job itself would be easy enough. If I could give it to
someone who didn't have to do anything on the side, I would make
him very happy. But then this person wouldn't be an artist and the
whole thing would go wrong. Someone who can divide his energies
more elegantly than I can will have to come along. His age is of sec-

Mural Painting, 1924, 128
Wandbild
Watercolour on cotton, coloured paste on
paper mounted on cardboard, 25.4 × 55.1 cm
Paul Klee Foundation, Kunstmuseum, Berne

ondary importance."[37] He started teaching in Düsseldorf in autumn 1931, with four students. Not till 1933 did he find a suitable flat for Lily and himself. Only a few days before they were due to move in, Paul Klee was sent his dismissal, with immediate effect. In December the Klees emigrated to Switzerland.

Klee had accepted the invitation to join the Bauhaus after he had had his first big success. The lucrative sales exhibitions from 1917 onwards were followed in 1920 by the first big retrospective at the gallery of his art dealer Hans Goltz in Munich; two monographs were published in 1920 and a third one came out the following year. He had successfully struggled with various forms of art, and was to extend his mastery over the next ten years. He had started to see himself as a painter in 1914, but he never lost sight of drawing, which continued to be one of the main components of his work. He remained loyal to the combination of various techniques and developed new ones in the years to come. Conventional information on the techniques used, such as "oil on canvas" or "watercolour", are seldom to be found on his pictures.

The structure of the ground is always an important element in the picture, as we have already seen in the 1914 work *Teppich der Erinnerung* (*Carpet of Memory*, p. 29). He returned to the formula used in this picture when he painted *Der Gott des nördlichen Waldes* (*The God of the Northern Woods,* p. 51) in 1922. The picture, with its shades of purple, green and yellow, appears very dark. It is covered with x's and seems to be divided into a mass of small squares without, however, there always being a contrast in colour between them. If we look at the picture from a distance, we see in the middle a face made up of sharply outlined geometrical shapes vaguely reminiscent of a

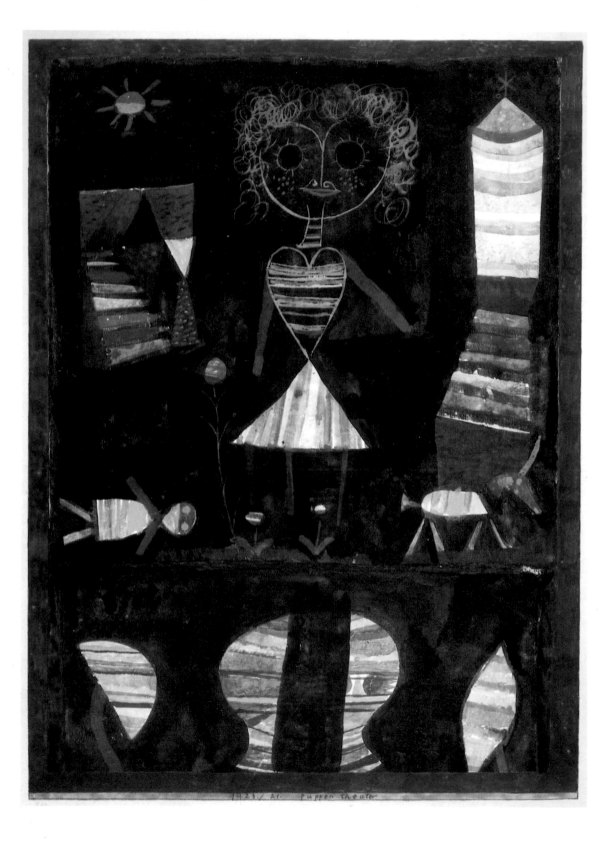

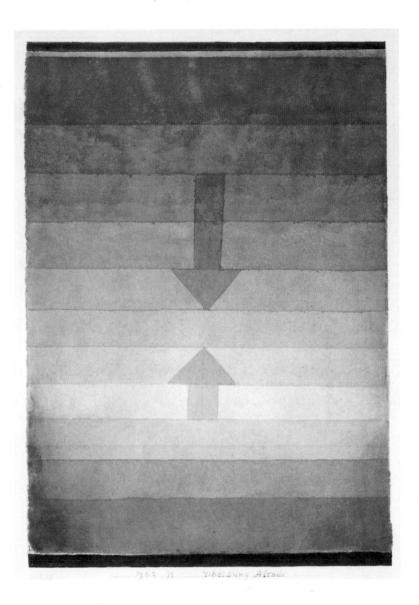

Separation in the Evening, 1922, 79
Scheidung abends
Watercolour, 33.5 × 23.5 cm
Felix Klee Collection, Berne

Puppet Theatre, 1923, 21
Puppentheater
Watercolour over chalk and glue ground on
packing paper, mounted on cardboard,
52 × 37.6 cm
Paul Klee Foundation, Kunstmuseum, Berne

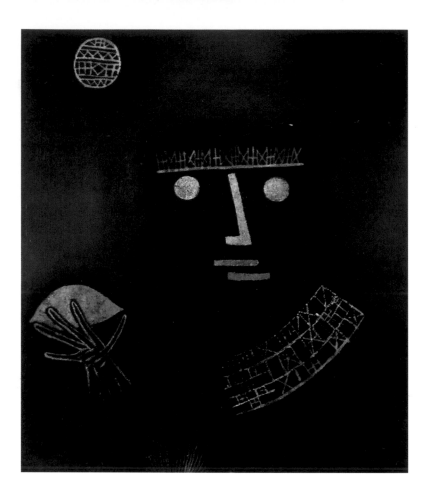

Pablo Picasso or Georges Braque. The way the face mysteriously appears from out of the dark background is explained by the title.

The structure of two other watercolours Klee painted in the same year is completely different. They can be linked to his work as a Bauhaus teacher. Presumably influenced by Johannes Itten's colour bands, Klee based both pictures on strips of colour and added those arrows that for a long time were typical of his work. These two abstract compositions were also given a meaning by the title added by Klee.

In *Scheidung abends* (*Separation in the Evening*, p. 57) there are horizontal strips of colour in shades ranging from dark brown at the bottom of the picture through ochre to a pale, almost white yellow running across the picture. These four strips take up a third of the picture. The remaining two thirds are dominated by seven lilac strips which start off dark at the top and become progressively lighter until they border on the very pale strip which – as the eighth strip – can be counted as lilac. Two arrows – in dark lilac and ochre – approach each other vertically and are separated from each other by the middle strip, i.e. the sixth one from the top. The title of this completely ab-

Black Prince, 1927, L 4 (24)
Schwarzer Fürst
Oil on white tempera on canvas with black ground, 33 × 29 cm
Kunstsammlung Nordrhein-Westfalen, Düsseldorf

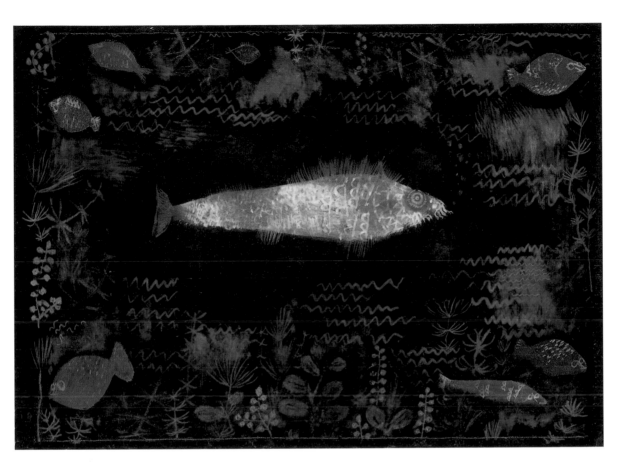

stract watercolour conjures up the evening dusk. The horizon can still be seen, the sky has already turned lilac, there is only a thin strip of light shining upon the earth before it finally disappears. Klee used a similar method in his *Betroffener Ort* (*Stricken Place*, p. 46).

In stark contrast to these two pictures, Paul Klee's "infantile art" reaches its peak at the beginning of 1923 in *Puppentheater* (*Puppet Theatre*, p. 56). *Harmonie aus Vierecken mit Rot, Gelb, Blau, Weiss und Schwarz* (*Harmony of Rectangles in Red, Yellow, Blue, White and Black*, p. 53), one of Klee's few strictly abstract pictures, and also *Der Seiltänzer* (*The Tightrope Walker,* p. 50) all date from this same year.

Der Seiltänzer (*The Tightrope Walker)* is a good example of one of the techniques Klee developed in Weimar, the oil transfer drawing. Aided by a piece of paper covered with black oil paint, he transferred a drawing onto another piece of paper or surface used for painting. The lines of the tracing appear slightly blurred or frayed, and near them are smudged patches as a result of the pressure applied in tracing. Klee then added watercolours, the dominant colour of which is pink, and framed it above and below with grey, cloudy strips.

The Goldfish, 1925, R 6 (86)
Der Goldfisch
Oil and watercolours on paper, mounted on cardboard, 48.5 × 68.5 cm
Kunsthalle, Hamburg

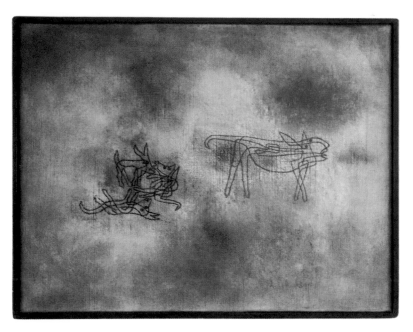

"Colour is firstly a quality. Secondly, it is weight, for it not only has a value in terms of colour, but also in terms of light and dark. Thirdly, colour also determines measurement, for, in addition to the values mentioned above, it also has its limits, its dimensions, its expansion, its measurable size.
Light and dark is firstly weight; secondly, in its expansion and limitation it determines measurement. But a line merely determines the measurements."
Paul Klee, lecture held in January 1924

She Bellows, We Play, 1928, P 10 (70)
Sie brüllt, wir spielen
Oil on canvas, original frame painted,
43.5 × 56.5 cm
Paul Klee Foundation, Kunstmuseum, Berne

In his self-portrait *monsieur Perlenschwein* (*monsieur Pearly Pig*, p. 54) of 1925, he succeeded in combining geometrical shapes, objective representation, negation of artistic style and a self-portrait. Here, as in other pictures of this period, Klee used a spray technique whereby he covered part of the paper with a stencil and sprayed the free places with water colours. This portrait is dominated by two square eyes, and the right one has been turned round to form a rhombus.

With this pair of eyes, Klee was referring to the physicist and philosopher Ernst Mach's "The Analysis of the Sensations and the Relations of the Physical to the Psychic", which Klee had been familiar with since 1905. The theories of Mach and the psychologist Friedrich Schumann (1863–1941), who had been influenced by Mach, particularly influenced Klee's teaching at the Bauhaus. In *monsieur Perlenschwein*, he was directly referring to experiments by Mach showing that, although the square and rhombus are geometrically identical, they are not perceived as such. The rhombus appears dynamic and larger than the static square. Klee counteracted this effect by making the square eye a little larger than the rhombus.

Der Goldfisch (*Goldfish*, p. 59), which Klee had painted a short while previously, contrasts with this cool watercolour based on the psychology of perception. In the dark blue water swims a patterned goldfish with short red fins, a red tail and a red eye, in the middle of the picture. It is surrounded by blue water plants and waves caused by the little red fish as they try to flee from the big fish. The blue of the plants and the red of the fish partly merge to form lilac.

It was pictures like this that made Klee famous in those days, and not works like *monsieur Perlenschwein*. *Der Goldfisch* has

Coloured Lightning, 1927, J 1 (181)
Bunter Blitz
Oil on canvas over cardboard, mounted on wood, original frame painted, 50 × 34 cm
Kunstsammlung Nordrhein-Westfalen, Düsseldorf

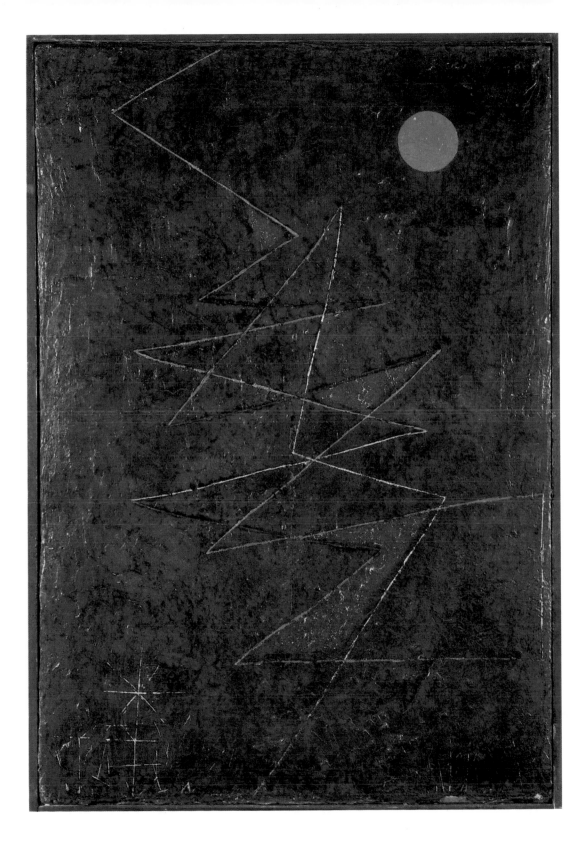

Temple Quarter in Pert, 1928, T 10 (200)
Tempelviertel von Pert
Watercolour, pen and Indian ink on gauze with
plaster and varnish ground, mounted on card-
board, framed with gouache, c. 27.5 × 42 cm
Sprengel Museum, Hanover

Highroads and Byroads, 1929, R 10 (90)
Haupt- und Nebenwege
Oil on canvas, 83 × 67 cm
Museum Ludwig, Cologne

prompted a variety of responses from Klee's critics: "With the compo-
sure of a god, he divides the blue element . . . the Golden Fish is . . . a
miracle in size and beauty. Everything submits to it, everything is at
its command . . . An image of the world in which Klee includes him-
self as a poet and painter."[38] Or: "The glistening miracle fish, in transi-
tory, energy-filled motionlessness, illuminates the dark blue dusky
world into which the little red fish flee."[39]

In 1928, Klee went to Egypt. He had not undertaken any more
long trips since he had been to Tunisia. But, as we can see from his
letters to Lily, this country by no means made as great an impression
on him as Tunisia had done. "I brought back completely different im-
pressions of Tunisia and am convinced that Tunisia is much purer.
The mosques in Kairouan even show that Tunisia has always been
purer."[40] He worked his new impressions into extremely abstract pic-
tures divided up by lines. In *Hauptwege und Nebenwege* (*Highroads
and Byroads*, 1929 – p. 62) horizontal stripes at varying distances
apart are divided up into patches of different colours by vertical lines
set at varying angles across the picture; the result is a restless net-
work. The gradients and terracing of the lines suggest a landscape per-
spective. The agreement of the pale colours has been lightened on the
"highroad" to form a luminous path and comes to rest in the continu-
ous blue horizontal strips above the "horizon". After the Egyptian
trip, Klee also worked on pictures that are geometrically more severe
in structure, the basic graphic pattern of which he took up in 1930 in
Individualisierte Höhenmessung der Lagen (*Individualized Measure-
ment of the Strata*, p. 71). A quotation from Klee's *Visual Form*, his
final concept for his tuition at the Bauhaus, could underlie this pic-
ture: "The individual part of this example shows us a number of indi-
viduals who disrespectfully differ from each other. Where they are
structures, the structure is based on individual numbers . . . This . . .

63

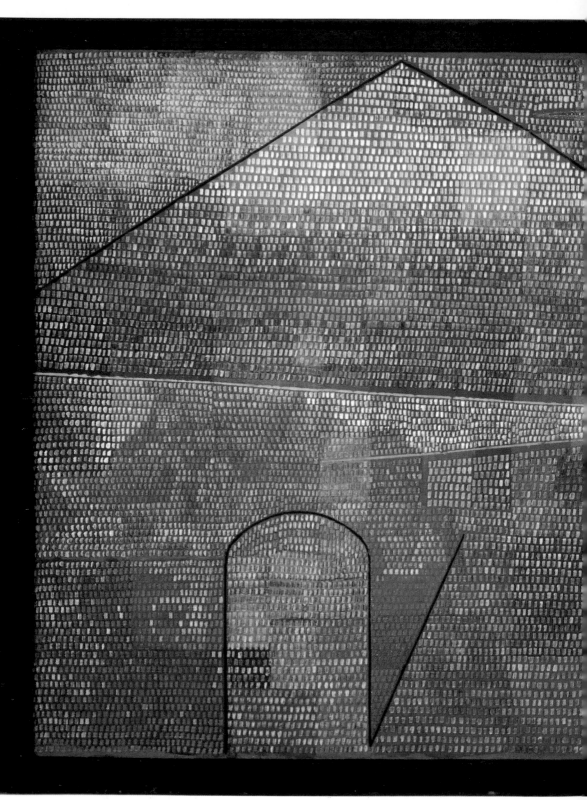

Ad Parnassum, 1932, X 14 (274)
Oil on canvas, stamped with dots and lines,
100 × 126 cm
Kunstmuseum, Berne

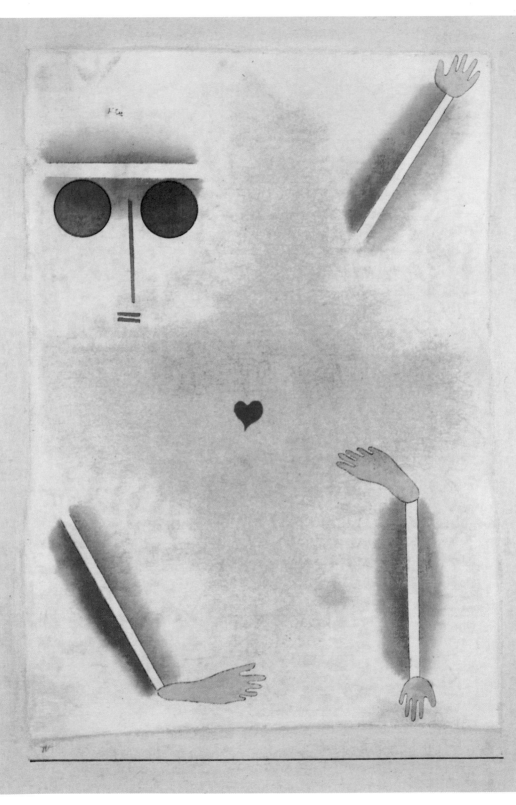

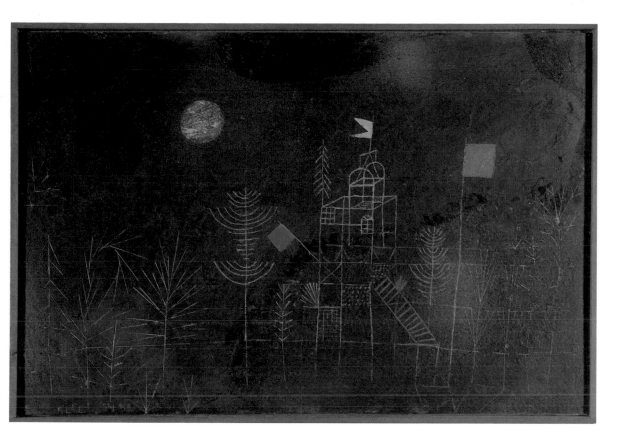

example is, so to speak, a symbol of a happy individual or happy individuals able to adjust rigidly to the structural regularity on the wide-area dimension, without this being detrimental to their individual characters."[41]

Klee, who had spent all his life working on small-scale pictures, created one of his largest works while in Düsseldorf. *Ad Parnassum* (1932 – pp. 64 – 65) combines various techniques and compositional principles. At first glance, it looks like a large mosaic with thick lines drawn across it. A small-meshed network in various colours encloses white embossed squares, some of which have had other colours superimposed on them. A few thick lines, also stamped on, allow an architectural structure to take shape in the midst of the flickering sea of colour. The title identifies it as the seat of Apollo and the Muses. An orange circle made up of a mass of tiny dots is, with its uniform colour, the only area of calm. It is above the "roof" of Parnassus and can be interpreted as the sun.

In spite of the flickering colours, this picture radiates complete calm. Klee had a regular income, as he had had during the Bauhaus period, with only four students, but by no means did he have as many obligations as in Weimar and Dessau. Thus, freed of financial worries, he was able to devote most of his time and energies to his own art. He had striven for and reached the top of "Parnassus".

Pavillion Decked with Flags, 1927, K 5 (15)
Beflaggter Pavillon
Oil on cardboard, 40 × 60 cm
Sprengel Museum, Hanover

Has Head, Hand, Foot and Heart, 1930,
S 4 (214)
Hat Kopf, Hand, Fuss und Herz
Watercolour and pen on cotton, mounted on
cardboard and hardboard, 41.5 × 29 cm
Kunstsammlung Nordrhein-Westfalen,
Düsseldorf

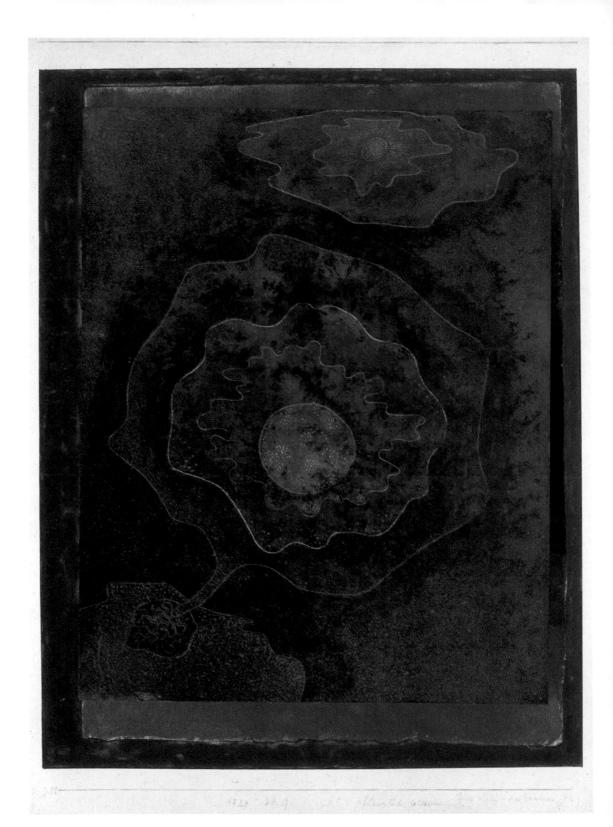

The Place of the Twins, 1929, 3 H 21 (321)
Die Stelle der Zwillinge
Watercolour on paper, mounted on cardboard, 27.5 × 30.6 cm
Paul Klee Foundation, Kunstmuseum, Berne

Vegetal-Strange, 1929, 3 H 17 (317)
Pflanzlich-seltsam
Brush drawing in water-based paint over watercolour on paper
with black ground over watercolour-toned paper, mounted on card-
board, 33.1 × 25.6 cm
Paul Klee Foundation, Kunstmuseum, Berne

Rhythmical Severer and Freer, 1930, O 9 (59)
Rhythmisches strenger und freier
Gouache on paper, 47 × 61.5 cm
Städtische Galerie im Lenbachhaus, Munich

Individualized Measurement of the Strata, 1930, R 2 (82)
Individualisierte Höhenmessung der Lagen
Pastels combined with paste on paper with black ground, mounted
on cardboard, 46.8 × 34.8 cm
Paul Klee Foundation, Kunstmuseum, Berne

1930. R.2. individualisierte Höhenmessung des Lagers

"Struck from the List"

On 30 January 1933, Adolf Hitler was appointed chancellor of the German Reich. On that very evening, Paul Klee wrote his wife a letter analyzing the new situation in the Reichstag. "It is a 'democratic' cabinet which can thus find a majority on the right of the parliament as long as it doesn't try to govern in a purely radical manner." He then expresses his fears that "Hitler is drifting away from Papen and will completely go off the rails". He commented, "But a man has his own thoughts and tries to give his view . . ." and then added resignedly, "I no longer believe there's anything we can do to alter things. The masses are not suited to real things, stupid in this respect."[42]

Although Klee was worried about political developments in Germany and saw it was possible there would be a putsch, and although he was very early on subject to personal attacks, he nevertheless did not draw the necessary conclusions. Two days later there was already an article in the National Socialist paper *Die Rote Erde* smearing the Düsseldorf Academy as a stronghold of Jewish artists. Among other things, it said: "Then that great fellow Klee comes onto the scene, already famed as a Bauhaus teacher in Dessau. He tells everyone he's a thoroughbred Arab, but he's a typical Galician Jew."[43]

Klee seems to have read the article, for that very day he wrote to Lily, "At the moment there's this unpleasant feeling pressing in my stomach . . . But then why do I go and read papers (!) other than ours."[44] The letter closes with the plain statement that his superior was now "a Hitlerian teacher from Hanover" – in other words, that the director of the Academy, Walter Kaesbach (1879–1961), had been dismissed without notice. But even then Klee still did not see any danger to his livelihood. A few days later he told Lily that there was, as yet, no excitement at the Academy over the changes at the Ministry of Culture, closing his letter with the words, "But what do the likes of us understand."[45] He obviously understood a great deal. But he suppressed his fears and, in spite of all the writing on the wall, was hoping to keep his job.

Neither did the fact that in March his house in Dessau was searched in his and Lily's absence prevent him from renting a relatively expensive house in Düsseldorf and giving notice of his intention to vacate the Dessau home. On 6 April he wrote to Lily from Düsseldorf: "I admit that all this uncertainty about my job and income can be most unsettling. But there's no point in getting worked up about it;

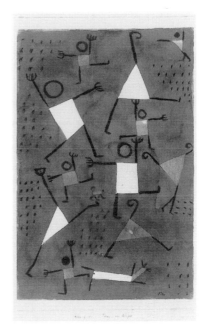

Dancing From Fear, 1938, G 10 (90)
Tänze vor Angst
Black watercolour on paper, mounted on cardboard, 48 × 31 cm
Paul Klee Foundation, Kunstmuseum, Berne

Struck from the List, 1933, G 4 (424)
Von der Liste gestrichen
Oil on transparent wax paper, 31.5 × 24 cm
Felix Klee Collection, Berne

73

Marked Man, 1935, R 6 (146)
Gezeichneter
Oil and watercolour on gauze with thickly-applied ground, mounted on cardboard,
30.5 × 27.5 cm
Kunstsammlung Nordrhein-Westfalen,
Düsseldorf

on the contrary – it makes you ill if you do . . ." He was unambiguous on the matter of what was known as "proof of Aryan ancestry". "I'll provide it if I'm officially asked to do so. But it's below my dignity to initiate action against such primitive accusations. For even if I were a Jew and did come from Galicia, this would alter neither my own worth nor that of my work one iota. My personal point of view is that a Jew and a foreigner is of no less intrinsic value than a German and a native, and I must not abandon it of my own accord, for if I did I would appear to posterity in an absurd light. I would rather cause myself trouble than become the tragicomic figure of one striving for the favour of those in power."[46]

He made this declaration the day before the Law on the Re-Establishment of the German Civil Service, excluding all so-called non-Aryans from state service and in fact effecting their instant dismissal, came into force. In accordance with the first section of this law, which stated that "Only those of German or related blood can become civil servants", Paul Klee now had to prove his ancestry if he was to remain at the Academy. He applied for the appropriate documents relating to his grandparents. But these were of little use to him for, according to this law, even those civil servants whose "previous political activities do not guarantee that they will at all times and without reserve support the national state"[48] could also be dismissed. This wording opened the door wide to despotic caprice. On 21 April 1933 Klee noted in his diary, "with immediate effect(!)".[49] It was an irony of fate that this certificate of "Aryan" descent was not sent to his address in Berne until 14 June 1935.

Although he had lost his job, he and his wife still moved into the house he had rented in Düsseldorf on 1 May 1933. He must have cherished the same fateful illusion as many others critical of the Nazi state or even put up resistance to it. Thomas Mann's son, Klaus Mann, wrote about this mood in his memoirs: "We kept assuring ourselves, but without real conviction, that the nightmare would not go on for long. A few weeks, a few months perhaps. Then the Germans would have to see sense and get rid of the disgraceful regime."[50]

In the autumn, the Klees decided to leave Düsseldorf. In the long term, they were no longer in a position to pay the rent for their house in any case. They very soon rejected their initial idea of moving out into the country but staying in Germany. Gallery owner Alfred Flechtheim (1878–1937), who had taken over from Goltz in 1925 as Klee's sole representative, was no longer able to keep to his contract, for he himself was being smeared as a Jew. With his approval – and in his presence – Klee signed a new contract with Daniel-Henry Kahnweiler (1884–1979) in Paris. On 23 December, Paul Klee returned to Berne for good. On the eve of his move he wrote to his son: ". . . I've been cleared out. Tomorrow evening I will most probably be leaving this place . . . I've grown a little older during the past few weeks. But I won't let any venom spill over, at least in no more than humorously measured doses."[51]

Klee did a lot of painting and drawing during his last year in Germany. The list of his works runs to 482 pictures for 1933. His per-

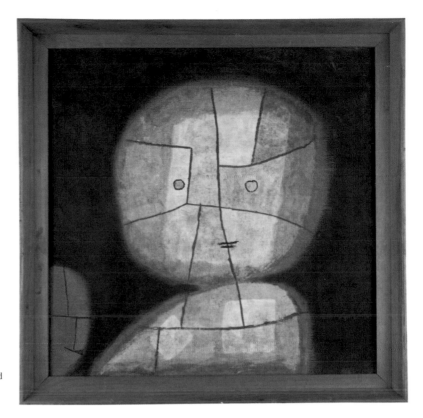

Bust of a Child, 1933, D 20 (380)
Büste eines Kindes
Waxed watercolours on cotton cloth, mounted
on plywood, original frame, 50.8 × 50.8 cm
Paul Klee Foundation, Kunstmuseum, Berne

sonal distress is expressed in one of the last pictures he painted that year. As was the case after the failed revolution of 1919, when he gave visual form to his withdrawal from politics and reality in his self-portrait called *Versunkenheit* (*Absorption*, p. 41) – which he paraphrased in his famous words, "I cannot be grasped in the here and now . . ." – he now once again painted a self-portrait (p. 72). As in *Versunkenheit*, his eyes are closed, his mouth tightly shut. But the generous, radiantly calm surface treatment has given way to a broken surface which communicates uncertainty. On the left of the head, crossing his forehead and cheek, there is a large X. The title, *Von der Liste gestrichen (Struck from the List)*, tells us the meaning of the picture. Klee had not only lost his professorial chair at the Academy; as an artist he was now worth nothing in Germany. He could now leave. This was not "venom [. . .] in humorously measured doses". The dark colours, the facial expression – they all show us a grief and despair he never put into words in quite the same way. When writing, he retreated to the commonplace.

Similar emotions are apparent in his *Büste eines Kindes* (*Bust of a Child*, p. 75), which appears to have been painted in the second half of 1933, but before his self-portrait. Almost the entire picture is taken up by the head and shoulders of a child against a brown background.

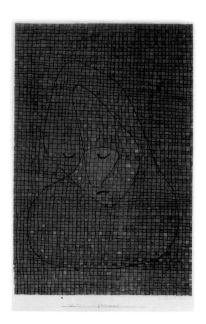

The round head is covered with red lines. Round, blue eyes stare intently at us. There is a red line running from the forehead, through the mouth and down to the shoulders and dividing the face into two halves. The face and eyes seem to want to impart to us a knowing sorrow.

In Berne, the Klees moved into a three-roomed flat and renewed old friendships from their youth. Klee painted, although not as much as earlier. In 1934 he listed 219 works, and the following year it was only 148. For Christmas 1934, he gave Lily the picture called *Trauernd* (*Mourning*, p. 76), which, like his child's bust and self-portrait of 1933, bears witness to great personal suffering. A network of thin lines gives the impression of a mosaic, and on top of this there is a bust drawn with one single line. The head is bent forward and down, the eyes closed, the corners of the mouth turned down. Klee does not seem to have been very happy in Berne, even though he had tried to apply for Swiss nationality immediately after his arrival. He was told, however, that he would have to wait five years before he would be able to do so.

A year later he painted another picture reflecting his mood and reminiscent of his child's bust of 1933. Certainly, *Gezeichneter* (*Marked Man*, p. 74) does not depict a child's head, but with its round face and round eyes, it is very similar to one. At several points the lines cutting across the face form an X, "striking" the marked man "from the list". Klee missed not having any obligations, he missed not being in the streamline of events, not being part of a wider context. Neither was the big retrospective opened at Berne art gallery on 23 February 1935 and then shown at Basle and Lucerne of any consolation to him. He fell seriously ill that same year. The diagnosis was 'measles', but this turned out to be wrong. He had progressive scleroderma, a rare disease of unknown cause that hardens the skin and makes the mucus membranes dry up and which is usually fatal.

The outbreak of the disease can also be viewed in the context of his situation, which Klee felt to be utterly hopeless. His work stagnated. Twenty-five items are listed for 1936. By this time the diagnosis had been made, and that summer Klee twice went away for treatment to a health resort. He only mentioned his illness in passing when writing to Lily, but to begin with he was paralyzed by the thought of having to die soon. But then, in the final years, he considerably increased his productivity again. In 1937 he created 264 works; in 1938, with 489, it was already nearly twice as many; the list for 1939 runs to 1,254 pictures – more than ever before in one year.

His style changed once more and the pictures gradually became larger. He was prepared to put up with the discomfort of the small flat in which he had far less room than in his studios at the Bauhaus and the Düsseldorf Academy. The subjects covered by the pictures continued to express his twofold view of life, examining his personal fate and the political situation in Germany, but still full of his wit and his joy in depicting life. For example, in 1937 he painted his *Musiker* (*Musician*, p. 77). With its "matchstick man" effect and thick black lines, it seems to depict Klee's inner conflict.

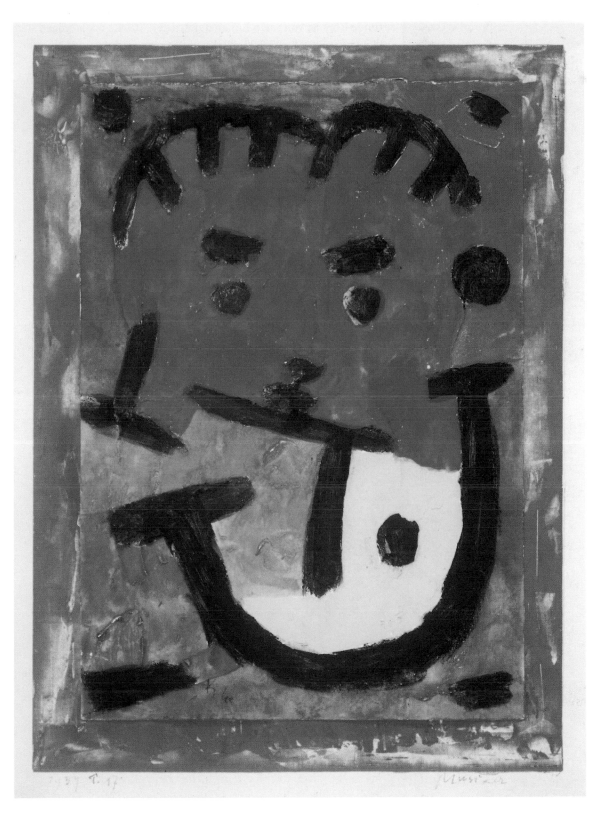

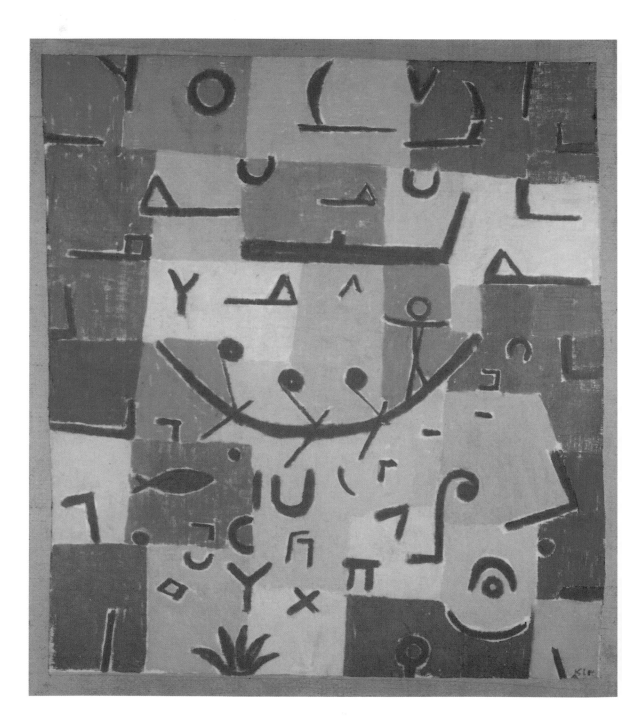

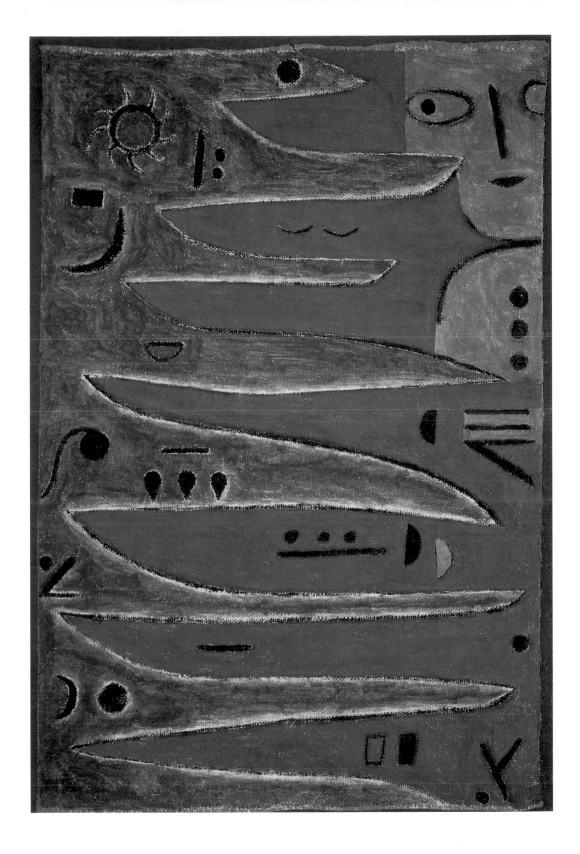

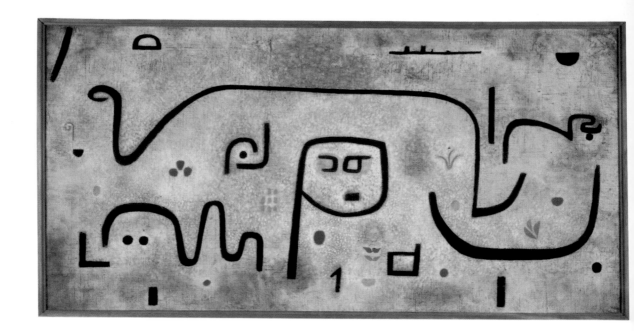

Insula dulcamara, 1938, C 1 (481)
Oil on newspaper, mounted on burlap,
88 × 176 cm
Paul Klee Foundation, Kunstmuseum, Berne

Revolution des Viaduktes (*Revolt of the Viaduct*, p. 93) has been called a historical picture, Klee's contribution to anti-fascist art. It refers directly to the political situation in Germany as it was then. In contrast to this picture, *Legende vom Nil* (*Legend of the Nile*, p. 78) expresses a positive outlook on life: golden signs similar to hieroglyphs, some of which are recognizable as boots, fish and plants, have been strewn on interconnected square boxes in various shades of blue. The Nile is also 'populated' by letters, eyes and incomplete clefs. Here, Klee is again conjuring up his journey to Egypt, but not – as he did in 1929 – purely abstractly, but, by means of the hieroglyphs, in a picture containing a high degree of abstraction.

In the following year, in 1938, Klee worked even more intensely with hieroglyphic elements. He placed signs and lines, usually in black, on various coloured backgrounds. They could certainly represent objects or people, such as is the case in the pictures *Nacht-Blüte* (*Night Bloom*) or *Der Graue und die Küste* (*The Grey One and the Coast*, p. 79); or they could serve to create a greater degree of abstraction, as with *Park bei Lu(zern)* (*Park near Lu(cerne)*, p. 81). The pictures are gloomy, distressing, depending on the colours used in them, or they give expression to Klee's frequently positive view of life. He was perhaps even hopeful he would get well again.

The inherent ambivalence of these works was captured most clearly in one of the last pictures of that year. *Insula dulcamara* (p. 80), measuring 88 by 176 cm, is also one of the largest pictures Klee ever painted. Even the title, containing as it does the Latin words "dulcis" (sweet) and "amarus" (bitter), is an indication of the conflict. Klee gave his "bitter-sweet island" a pale background. It consists of soft shades of pink, yellow and blue that are not sharply divided from

one another, but instead are cloud-like in character. There are delicate plants and flowers growing in this apparently friendly "landscape" intermingled with water. Sharp black lines spoil the idyllic scene. The white face in the centre of the picture, with its dark eyes outlined in black, symbolizes death.

In January 1938, Klee wrote to his daughter-in-law for her birthday, putting into words the thoughts expressed in *Insula dulcamara*: "We mustn't be discouraged by the fact that not only easily digestible matter will weave its way in. We must just continue to hope that heavy material can keep a balance with the other forces. This certainly makes life a more thrilling business than if it were Biedermeier-bourgeois. And each of us must take sweet and sour from the two bowls according to taste . . . With care and intelligence, no one will succumb to great illusion!"[52]

Bitterness, fear and grief dominate many of the pictures painted in 1939. Examples of this are *Angstausbruch III* (*Outbreak of Fear III*; p. 85) and *Friedhof (Cemetery)*. These two works are unambiguous, both as far as the title and the way they are painted are concerned.

In 1939, when he had been living in Switzerland for five years without interruption, Klee was at last able to apply for naturalization. This "formality" turned out to be more difficult than he had expected. Although he had been born in Switzerland and had grown up there, strict standards were applied. His art proved to be the biggest hurdle. In conservative Switzerland, where a National Socialist party had a large following during the 30s, modern art was associated with left-wing politics. It had very few supporters. When the big Nationale Kunstausstellung (National Art Exhibition) took place in Berne early in the summer of 1936, the avant-garde was not represented. Parallel to this, the Kunsthaus Zurich organized an exhibition entitled "Contemporary Problems of Swiss Painting and Sculpture", showing works by Paul Klee, Hans (Jean) Arp (1887–1966) and Charles Le Corbusier (1887–1965), thus acclaiming the three internationally most important representatives of modern art in Switzerland. The newspaper *Luzerner Nachrichten* published a brief and precise description of the two exhibitions: "On 13 June the Kunsthaus Zurich opened an exhibition of those young forces whose presence was undesirable at the 'Nationale' in Berne. As well all know, the 'Nationale' in Berne has emphasized our most conspicuous peculiarity, our sense of reality. Dreamers such as Surrealists, designers and lovers of abstract art were ignored. The Zurich exhibition has now collected these 'ignored' revolutionaries of art into a front."[53]

The heated atmosphere became worse during the following years, and Klee was closely examined because of the cultural and political implications of his art. The curator of the art museum in Berne was asked to write a report; Klee was interrogated by the police; others were questioned at length. All this resulted in secret police reports accusing him of degenerate art – this time by the Swiss. The reports claimed that one day Klee's extravagance might make him go mad, that famous Swiss painters had called his style as such sinister, and that if it ever became generally accepted, it would be "an insult to

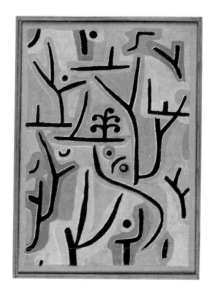

Park near Lu(cerne), 1938, J 9 (129)
Park bei Lu(zern)
Oil on newspaper, mounted on burlap,
100 × 70 cm
Paul Klee Foundation, Kunstmuseum, Berne

Doppelschwanzdreiohr, 1939, FG 3 (1063)
Pencil on paper, 29.5 × 41.9 cm
Felix Klee Collection, Berne

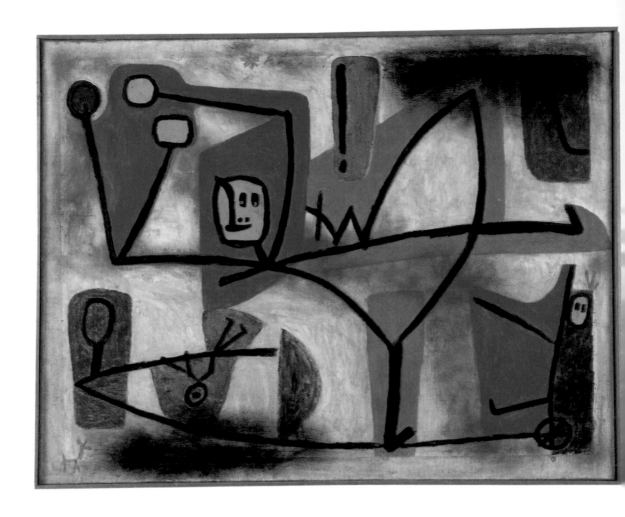

Exuberance, 1939, Pqu 11 (1251)
Übermut
Coloured paste and oil on packing paper,
mounted on burlap over a stretcher,
100 × 130 cm
Paul Klee Foundation, Kunstmuseum, Berne

true art, a decline in the good taste and sound ideas of the people".[54] It also stated that Klee's art was furthered by Jewish dealers for financial reasons only. These charges were the same as those of the Nazis in the Third Reich. In the notorious exhibition of "Degenerate Art" in Germany, Klee's pictures had been compared to the art of the mentally ill. He had already been smeared as a "Galician Jew" in 1933; now he was "only" being associated with Jewish dealers – but with the same intentions.

Nevertheless, the Swiss authorities approved his application. Now the Berne municipal authorities merely needed to give him civil rights, for which he had to make a separate application. He did so on 15 January 1940. More interrogations followed, and then at last a final decision on the "Klee case" was put on the agenda of the city council meeting on 5 July 1940. This item was then struck from the list: Klee died on 29 June. His desire "to be a citizen of this city", which he had expressed in the last sentence of his curriculum vitae of 7 January 1940, remained unfulfilled.

Paul Klee did not die in Berne. He had gone to Ticino in May for further treatment. On 8 June he was admitted to hospital in Locarno, where he died on 29 June. His big *Stilleben* (*Still Life*, p. 90) was still standing, unsigned, on his easel in his flat. This upright picture differs greatly in style from his previous works. Here, Klee has given a relatively realistic rendering of various objects against a dark background. In the foreground, to the right, there is a yellow circle (a table?) strewn with flowers and with a green jug and a sculpture on it. In the top left-hand corner there are three vases containing a few flowers and a column standing on a red circle. In front of all this is a bulging, sausage-like object, as yet unidentified, floating in the air. Isolated from these two groups is the disc of the moon on the dark background.

Right at the front, on the left, there lies a sheet, one of its corners cut off, with one of Klee's drawings depicting an angel on it. He had drawn several angels in the previous years. This 'picture within a picture' is not a copy of one of Klee's already existing pictures. He did not put it onto paper again until later (1940), when he called it *Engel, noch häßlich (Angel, Still Ugly)*.

The painting was already finished by the end of 1939. Klee had had a photograph of himself standing in front it taken on 18 December, his 60th birthday. This was certainly not a coincidence. It is not known why he did not sign it nor why he placed it on his easel before leaving for Locarno. It has been said that he regarded this picture, which is now generally called *Stilleben (Still Life)*, but which he did not give a title, as his artistic legacy. This theory is certainly plausible, but still needs convincing proof.

On 4 July a memorial service was held for Paul Klee in Berne after he had been cremated in Lugano. The urn was not interred in the

Forgetful Angel, 1939, VV 20 (880)
Vergesslicher Engel
Pencil on paper, 29.5 × 21 cm
Paul Klee Foundation, Kunstmuseum, Berne

Puppet Drama, 1939, 19
Puppen-Drama
Pen and ink on paper, 27 × 21.4 cm
Paul Klee Foundation, Kunstmuseum, Berne

Eidola: Erstwhile Cannibal, 1940, V 10 (90)
Eidola: Weiland Menschenfresser
Chalk on paper, 29.7 × 21 cm
Paul Klee Foundation, Kunstmuseum, Berne

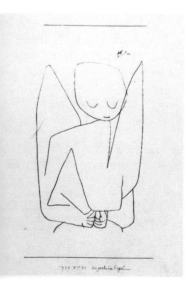

They All Go Running After!, 1940, G 5 (325)
Alles läuft nach!
Coloured paste on paper, mounted on cardboard, 32 × 42.4 cm
Paul Klee Foundation, Kunstmuseum, Berne

Outbreak of Fear III, 1939, M 4 (124)
Angstausbruch III
Watercolour on paper, mounted on cardboard, 63.5 × 48.1 cm
Paul Klee Foundation, Kunstmuseum, Berne

cemetery in Berne until 1946, after Lily's death. Felix Klee had the words that had been his father's manifesto engraved on the tombstone:

"I cannot be grasped in the here and now
For my dwelling place is as much among the dead
As the yet unborn
Slightly closer to the heart of creation than usual
But still not close enough"

Bell Angel (Schellen-Engel), 1939, AB 6 (966)
Pencil on paper, 29.5 × 21 cm
Paul Klee Foundation, Kunstmuseum, Berne

Double (Doppel), 1940, N 16 (236)
Coloured paste on paper, mounted on cardboard, 52.4 × 34.6 cm
Paul Klee Foundation, Kunstmuseum, Berne

Boating Fun on the Canal (Bootsvergnügen im Kanal), 1940, G 6 (326)
Coloured paste on paper, mounted on cardboard, 37.5 × 49.5 cm
Sprengel Museum, Hanover

OPPOSITE:
Flora on the Rocks (Flora am Felsen), 1940, F 3 (343)
Oil and tempera on burlap, original frame, 90 × 70 cm
Kunstmuseum, Berne

PAGE 90:
Untitled (Still Life), (Ohne Titel (Stilleben)), 1940
Oil on canvas, 100 × 80.5 cm
Felix Klee Collection, Berne

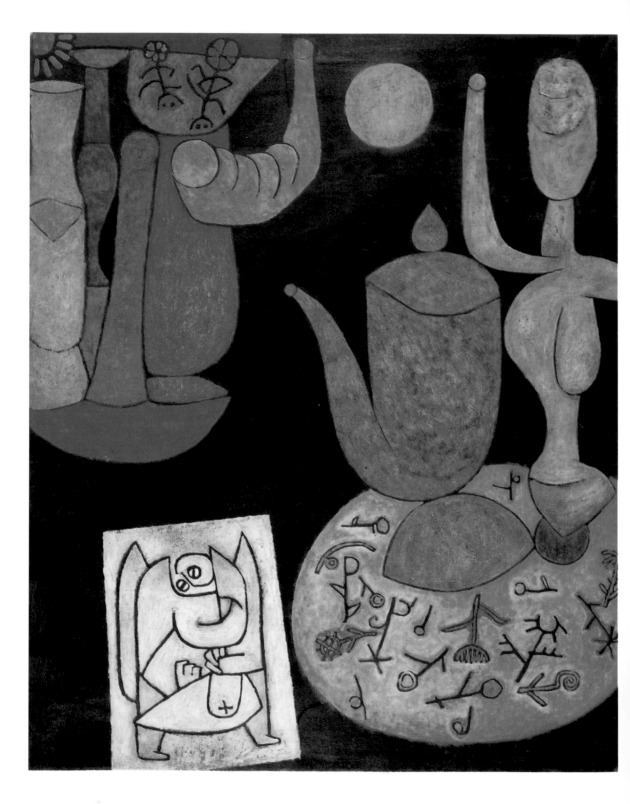

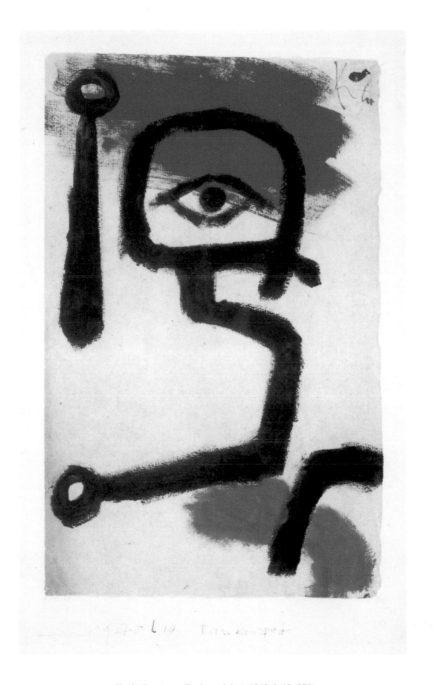

Kettle-Drummer (Paukenspieler), 1940, L 10 (270)
Brush and coloured paste on hand-made paper, mounted on cardboard, 34.6 × 21.2 cm
Paul Klee Foundation, Kunstmuseum, Berne

Picture Analysis:
Revolt of the Viaduct
(Revolution des Viaduktes)

1937, R 13 (153), Oil on canvas, 60 × 50 cm
Kunsthalle, Hamburg

In 1937 Paul Klee painted one of his best-known pictures. It is now in the Kunsthalle in Hamburg. It is generally agreed that it is a political, historical picture. There are differing opinions, however, on how it should be interpreted.

In 1937, the Nazi cultural bosses staged an exhibition of "Degenerate Art" in Munich. Five of Klee's oil paintings, nine of his watercolours and three etchings were shown. Afterwards, 102 of his pictures were confiscated from public collections. Not once did Klee express his opinion in writing on these events.

After his illness had hindered him from working for a year, Klee started painting again in 1937. The picture that took up most of his time that year was *Revolution des Viaduktes (Revolt of the Viaduct)*. He painted five pictures on the subject, and the one discussed here was the last in the series. Klee never displayed it at an exhibition, and it was not shown to the public until the memorial exhibition in Berne in 1940.

The small, upright painting has a relatively monochrome blue ground which in places tends towards mauve. On top of this there are single bridge arches in various colours and sizes walking towards the beholder. They are not marching in rows, but more as a disorderly crowd, an impression intensified by their differing sizes and colours. Yet for a long time

Design for the motorway bridge over the River Werra, by Fritz Tamms

critics agreed that Klee was showing the danger arising from totalitarian mass movements. Thus the arcades were marching "towards the beholder boding ill" (Geelhaar), a world was being stamped to ruins (Haftmann), and Schmidt saw them as brutal brown cohorts.

In an essay written in 1987, Werckmeister rightly questioned the validity of these interpretations. The yellow, orange, pink and red bridge arches, some of them squat, others thin and tall or with "legs" of differing thickness,

do not represent a "totalitarian mass movement", which would be marked by uniformity and regularity without acknowledging individuality. There is no doubt, however, that this picture shows different individuals.

Klee called the penultimate version of this picture *Brückenbogen treten aus der Reihe (Arches of the Bridge Break Ranks)*. It is a drawing very similar to the painting and conveys the impression of order being abandoned. When motorways started being built, bridge building gained in importance in National Socialist architecture. The arches stood there "in rank and file", their uniform height and width expressing conformity.

With Klee, the arches of the bridge shown here refuse to cooperate. They refuse to carry on being just a link in a chain; each one wants to exist on its own. To this end they "break ranks", make a "revolution". There they go marching towards the beholder, each arch of the bridge on its own – and not keeping in step. Their numerical superiority makes them aware of their strength. If there is anything they want to crush underfoot, then it is the order that has forced conformity on them.

This picture, with all its menace, is a declaration of war on the Nazis who, if they had been unable to impose complete artistic conformity, had at least successfully suppressed all individuality in art.

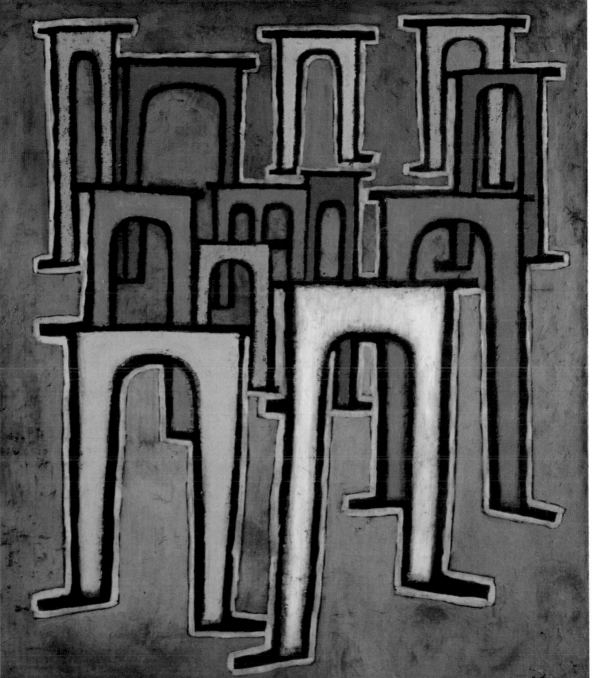

Paul Klee 1879–1940: A Chronology

1879 Paul Klee is born on 18 December in Münchenbuchsee near Berne. Has German nationality since his father, Hans Klee, is German. His mother, Ida Klee, née Frick, is Swiss. They also have a daughter called Mathilde.

1886–1897 After primary school, Paul Klee goes first to the Städtisches Progymnasium and then the Städtische Literaturschule. He learns to play the violin and becomes an associate member of an orchestra.

1898 After taking his school-leaving examination, he moves to Munich in October to study painting at the Art Academy. He is not given a place and is advised to get the necessary grounding at Heinrich Knirr's private school of drawing.

1899 Meets the pianist Lily Stumpf (1876–1946) at a musical soirée in December.

1900 In October Klee joins the painting class of Franz von Stuck (1863–1928) at the Academy.

1901 Leaves the Academy in March. Before his departure, he secretly gets engaged to Lily Stumpf. From October until May 1902 he travels to Italy with his student friend Hermann Haller.

1903–1905 Lives with his parents in Berne. He practises drawing from the nude, works at his series of etchings called *Inventionen* (Inventions), plays in the orchestra and writes theatre reviews. He goes to Paris in June 1905, where he sees Impressionist works, but does not, however, come into contact with modern art.

1906 Paul Klee and Lily Stumpf marry on 15 September and then move to Munich. Lily Klee-Stumpf earns their livelihood by giving piano lessons.

1907 Son Felix is born on 30 November. During the following years, Klee is mainly concerned with the housekeeping and bringing up his son.

1910 Kunstmuseum Berne holds Klee's first one-man exhibition.

1911 Klee meets Alfred Kubin in January and August Macke and Wassily Kandinsky in the autumn. He is now in contact with Der Blaue Reiter.

1912 17 of Klee's pictures are shown at the second Der Blaue Reiter exhibition at the Goltz gallery. He goes to Paris with Lily, where he meets Robert Delaunay and sees pictures by, among others, Pablo Picasso and Henri Matisse.

1914 Trip to Tunisia in April with Louis Moilliet and August Macke. Beginning of First World War in August. Klee expects to be called up.

Paul Klee, Berne, 1892

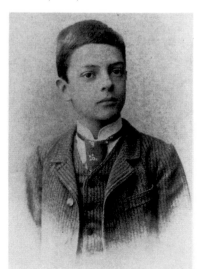

Hans, Lily and Paul Klee, Berne, 1906

Paul Klee, Munich, 1911

Felix Klee with 'Fritzi' the cat, Paul and his sister Mathilde Klee, Weimar, 1922

Wassily and Nina Kandinsky, Georg Muche, Paul Klee, Walter Gropius, 1926

1916 Called up to the German army. There is an exhibition at Der Sturm gallery in Berlin at which Klee's pictures sell well for the first time.

1918 Klee is discharged from the army shortly before Christmas and returns to Munich.

1920 In May, Hans Goltz holds a big retrospective in Munich with 362 works. Two monographs are published. In October Klee is invited to join the Staatliches Bauhaus in Weimar.

1924 The Bauhaus in Weimar is closed in December.

1925 The city of Dessau takes over the Bauhaus. Klee's *Pedagogical Sketchbook* is published as the second volume in the Bauhaus books series.

1926 Klee participates in the first group exhibition of the Surrealists in Paris.

1929 A big anniversary exhibition is held in the Kronprinzenpalais in Berlin on the occasion of his 50th birthday. At the same time, art dealer Alfred Flechtheim also exhibits 150 pictures in Berlin.

1930 Appointed to the Düsseldorf Academy. In the autumn he withdraws from his contract with the Bauhaus.

1933 Is dismissed without notice in April. In December, he and Lily emigrate to Switzerland.

1935 A big exhibition of his works is held in the Kunsthalle Berne.

1936 Klee's severe illness turns out to be progressive scleroderma. This year he produces only 25 pictures.

1937 Kandinsky and Picasso visit Klee in Berne. 17 of Klee's pictures are shown at the exhibition of "Degenerate Art" in Munich and 102 of his works in public collections in Germany seized. Klee resumes work.

1940 Klee dies in Locarno-Muralto on 29 June, shortly before being given full Swiss nationality. Big memorial exhibitions are held in Berne and New York. In 1946 his ashes are interred at the Schosshaldenfriedhof in Berne.

Klee in his studio at the Bauhaus, Weimar, 1924

Paul Klee, Berne, 1940

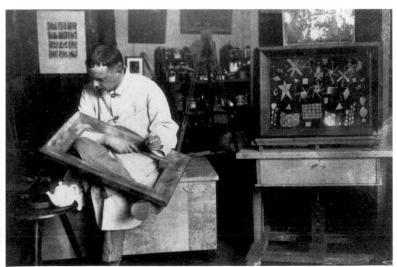

Notes

1 Leopold Zahn, *Paul Klee. Leben, Werke, Geist*, Potsdam, 1920, p. 5.
2 Paul Klee, *Tagebücher 1898–1918*. Textkritische Neuedition, bearbeitet von Wolfgang Kersten, Berne, 1900. Klee numbered each section; for purposes of simplification, we have listed these numbers in the text.
3 Will Grohmann, *Paul Klee,* Stuttgart, 1954.
4 Jürgen Glaesemer, *Paul Klee. Handzeichnungen*, 3 vols., Berne, 1973–1979; Jürgen Glaesemer, *Paul Klee, die farbigen Werke im Kunstmuseum Bern*, Berne 1976 (quoted here as Glaesemer, 1976); Christian Geelhaar (ed.), *Paul Klee-Schriften*, Cologne, 1976 (quoted here as *Schriften*).
5 O.K. Werckmeister, *Versuche über Paul Klee*, Frankfurt, 1981 (newly edited collection of the following essays: "Paul Klee und der 'Engel der Geschichte'", 1976; "The Issue of Childhood in the Art of Paul Klee", 1977; "Die neue Phase der Klee-Literatur", 1978; "Klee im Ersten Weltkrieg", 1979 (quoted here as Werckmeister, 1981); O.K. Werckmeister: "Kairuan: Wilhelm Hausensteins Buch über Paul Klee" in E.G. Güse (ed.), *Die Tunisreise*, Stuttgart, 1982; O.K. Werckmeister, "Von der Revolution zum Exil" in *Paul Klee, Leben und Werk*, Stuttgart, 1987 (quoted here as Werckmeister, 1987); O.K. Werckmeister: *The Making of Paul Klee's Career 1914–1920*, Chicago, 1989 (quoted here as Werckmeister, 1989).
6 See note 2.
7 Werckmeister, 1981, p. 132.
8 Quoted in Werckmeister, 1981, p. 173, note 39.
9 Felix Klee (ed.), *Paul Klee – Briefe an die Familie 1893–1940*, 2 vols., Cologne, 1979 (quoted here as *Briefe*).
10 Such as Tilman Osterwold, *Ein Kind träumt sich*, Stuttgart 1979.
11 Publisher's announcement for *Der Blaue Reiter*, Verlag R. Piper und Co., Munich, 1912, quoted according to Paul Vogt, *Der Blaue Reiter*, Cologne, 1977, p. 123.
12 *Die Alpen*, 6, 1912, p. 302, quoted according to *Schriften*, p. 97.
13 Quoted according to *Schriften*, p. 127.
14 Quoted according to Glaesemer, 1976, p. 29.

15 Will Grohmann, *Paul Klee*, Stuttgart, [4]1965, p. 55.
16 Quoted according to Ernst-Gerhard Güse, "Skizzen als Vollendung – August Macke in Tunis" in E.G. Güse (ed.), *August Macke, Gemälde, Aquarelle, Zeichnungen,* Münster, 1986, p. 103.
17 Quoted according to Glaesemer, 1976, p. 33.
18 *Ibid.*
19 O.K. Werckmeister, in his essay "Klee im Ersten Weltkrieg", 1979, to which he has added new research and published as a book (1989), has done pioneering work here. This chapter in particular is indebted to his work. I would like to take this opportunity of thanking him for his ideas.
20 *Briefe*, p. 482.
21 *Ibid.*
22 Werckmeister, 1981, p. 32 f.
23 To Kandinsky, 18 August 1914, quoted according to Werckmeister, 1989, p. 269, note 9.
24 17 October 1914, quoted according to Werckmeister, 1981, note 21.
25 Werckmeister, 1981, p. 87.
26 Quoted according to Glaesemer, 1976, p. 48.
27 Werckmeister, 1981, p. 63.
28 Quoted according to *Paul Klee. Das Frühwerk 1883–1922*, catalogue of exhibition at the Städtische Galerie im Lenbachhaus, Munich, 1980, p. 93.
29 Quoted according to *Paul Klee als Zeichner 1921–1933,* exhibition catalogue, Berlin, Munich, Bremen, 1985/86 (quoted here as *Klee als Zeichner*), p. 26.
30 Walter Gropius, "Ziele und Grundsätze des Bauhauses", quoted according to Giulio C. Argan, *Die Kunst des 20. Jahrhunderts 1880–1940*, Propyläen Kunstgeschichte, vol. 12, Frankfurt, Berlin, Vienna, 1985, p. 89.
31 *Ibid.*
32 *Briefe*, p. 984.
33 Quoted according to *Klee als Zeichner*, p. 29.
34 Draft of letter to Walter Gropius, quoted according to *Klee als Zeichner*, p. 168 ff.
35 *Briefe*, p. 1067.
36 *Briefe*, p. 1098.

37 *Briefe*, p. 1129.
38 Will Grohmann, *Der Maler Paul Klee*, Cologne, 1966, p. 100.
39 Christian Geelhaar, Paul Klee, Leben und Werk, Cologne, 1977, p. 57.
40 *Briefe*, p. 1074.
41 Quoted according to Werckmeister, 1987, p. 149.
42 *Briefe*, p. 1225.
43 Quoted according to Werckmeister, 1987, p. 39 f.
44 *Briefe*, p. 1226.
45 *Briefe*, p. 1230.
46 *Briefe*, p. 1233 f.
47 Quoted according to Hildegard Brenner, *Die Kunstpolitik des Nationalsozialismus*, Reinbek bei Hamburg, 1963, p. 182.
48 Quoted according to *ibid*, p. 40.
49 *Briefe*, p. 1241.
50 Klaus Mann, *Der Wendepunkt. Ein Lebensbericht*, Reinbek bei Hamburg, 1985, p. 286.
51 *Briefe*, p. 1240.
52 *Briefe*, p. 1282.
53 Quoted according to Werckmeister, 1987, p. 52.
54 Quoted according to *ibid.*

The measurements given after the titles refer to the size of the picture without the background or frame. The numbers correspond to those in Klee's own list of works.

We would like to thank the picture owners named in the captions for permission to publish the pictures and for letting us have copies. The photographs for the frontispiece and the illustration on p. 45 are by Hans Hinz. The illustration on p. 92 is in the book *Reichsautobahn* published by Jonas Verlag, who kindly lent us the copy of the picture. The photographs on pp. 94/95 and on the back cover are in the archive of Felix Klee in Berne, whom we would like to thank for his assistance. The illustration on p. 62 is courtesy of the Rheinisches Bildarchiv.